THE ARTS
AND
THE WORLD OF BUSINESS

A Selected Bibliography

by

CHARLOTTE GEORGI

The Scarecrow Press, Inc.
Metuchen, N.J. 1973

Library of Congress Cataloging in Publication Data

Georgi, Charlotte.
 The arts and the world of business.

 1. Arts--Management--Bibliography. I. Title.
Z5956.A7G46 658'.91'7 73-3380
ISBN 0-8108-0611-8

Copyright 1973 by Charlotte Georgi

TABLE OF CONTENTS

INTRODUCTORY NOTES AND ACKNOWLEDGMENTS

This bibliography is the result of something over three years of work in locating, acquiring, and processing the materials cited. Along the way, two preliminary fifty-page multilithed lists were also produced: The Arts and the Art of Administration (1970) and Management and the Arts (1972).

All of these publications were prepared in support of the courses designed for the Master's Degree Program in the Arts Management field of concentration, first offered in the fall quarter of 1969 by the Graduate School of Management of the University of California Los Angeles.

With some few exceptions, all materials described are located in UCLA Libraries, particularly the Graduate School of Management Library. For the most part, the books included are recent imprints and are English language, primarily American, publications.

Some further explanatory notes: Section XIX cites several bibliographies which note older imprints and foreign materials. No specific journal and periodical articles are listed per se. Instead, Section XVI suggests various indexes which provide access to the enormous amount of such material available. Section XVII lists selected basic journals and newsletters.

My special thanks are due to Professor Hyman R. Faine, founder and Director, and Mrs. Barbara Jacobsen, Administrative Assistant, of the Management in the Arts Program for their support, both moral and financial. I am particularly grateful to Professor Faine for his discerning foreword.

v

In my own library, Mrs. Helen Alexander, Associate Librarian in charge of Collection Development, showed continuous and most welcome interest in acquiring materials on the subject at hand. Miss Judith Truelson, Associate Librarian for Public Services, was a constant source of encouragement and support. Miss Ann Okitsu offered valuable assistance in compiling the initial rough draft.

Mrs. Susan F. Smith of the UCLA Art Library and Mrs. Audree Malkin of the Theater Arts Library made many helpful suggestions. Mrs. Jean Aroeste of the University Research Library Reference Department offered more inspiration than she will admit. Miss Ana Steele, Director of the Office of Research of the National Council on the Arts, has provided critical comments and correct information.

And, finally, it is thanks to the diligent intelligence as well as the clerical skill of Mrs. Terry Fate that everything was ever assembled to the actual point of typing the final draft copy.

Charlotte Georgi

Graduate School of Management Library
University of California Los Angeles
September 1972

FOREWORD

For some time there has been a growing recognition in both the performing and visual arts fields of the need for training arts administrator-managers in the arts.

The words "arts management" strike consternation, confusion and sometimes antagonism in the minds of some people when they are first heard. Images of a "manager" of an artist, resembling a "fight" manager or the manager of an actor or singer, flash by; sometimes the feeling of a contradiction in terms is engendered. How can an art which has its origin in creativity, the unexpected, the imagined, the unknown, be managed? It is as if one were to harness the heat and light of a lightning bolt. At other times the image is one of manipulation, of control of the arts, or of ends justifying the means.

These difficulties of joining the words "arts" and "management" to describe the activity of a specific human being become even more pronounced when they are used to describe a course of study, of training, of research and analysis. These were some of the basic puzzlements confronting those of us involved in the discussions in 1969 when we first met on the West and East Coasts to consider the need, the applicability and the possibility of establishing in the UCLA Graduate School of Business Administration (as it was then known) a center of training for arts administrators.

Participating in these discussions were faculty members of the Business School and the departments of Art, Dance, Music and Theater Arts of the UCLA College of Fine Arts, as well as practitioners, di-

rectors, executives of many of the arts institutions and organizations in the United States, and representatives of state and federal agencies involved in the arts. It was a highly knowledgeable, volatile, opinionated and vocal group.

The consensus that was reached among us was that there was definitely a need for training the future managers of arts institutions. Such training could best be achieved in a School of Management in cooperation with a College of Fine Arts where all the art disciplines and facilities were represented and available. It was further felt that the arts institutions in the Los Angeles area should have a close, direct and interdependent relationship with the training and educational process.

As a participant in the discussions on the East Coast, I felt, as many others did, that the existing methods of developing arts managers were inadequate to the present and future needs of the arts. This was true whether advancement was by working one's way up from "coffee getter," or by lateral movements from other fields such as law, accounting, fund raising or advertising, or even by being an "artist" first and becoming a manager when one had reached the end of his career as an artist.

Many of us felt that what the arts organizations needed were executives with skills in management equally as broad and developed as those possessed by managers of other types of human enterprises; that fundamentally a museum or a theater was an organization conceived by human beings, managed by human beings to achieve an objective of worth and need for human beings. In essence this met the definition of a manufacturing, distributive or service organization, and schools of management in the U.S. had been training individuals to do this very thing for many years with considerable success. Such schools and their faculties had been doing research, analyzing and developing theories, methods, approaches and concepts to make such organizations function effectively for the

purposes for which they were organized.

Then, as now, I felt that these methods could be applied successfully to arts institutions, for the benefit of the institutions, the creative artists, and the public which they served. There are, however, some fundamental differences between an automobile company and a symphony orchestra, between the manufacture of an automobile and the presentation of a symphony. These are crucial to the management of the organization and, of course, to the training of the manager.

For one, the auto manufacturer sells his car to make a profit for the owners of his company, while the director of the orchestra neither expects nor reaps any profits. In fact he knows that his orchestra's activities will generate a deficit. In other words he is, and would be, managing a "not for profit" organization.

For another, the arts institution has an obligation to the past, as well as to the present, to the preservation of classic art as well as the exhibition and presentation of the modern, and, as we are learning, to the encouragement of the innovator and the future creator who will supplant and supplement the classicist and the modernist.

As we at UCLA began to develop the academic program, the curriculum, the teaching methods and materials necessary for the training of our students, several things became clearly apparent. Our students would have to gain knowledge in statistics, accounting, economics, systems analysis, organizational behavior, marketing, model building, computer operations and managerial decision-making. These subjects were all being taught within the School of Management. There were teachers, reading materials, syllabi, texts, cases, films and many other sources of information and knowledge for them.

However, for the arts manager there were

many other areas which would have to be taught and in which the students would have to become proficient, to learn the issues and problems, to search for some of the answers and to begin to develop the skills and knowledge uniquely essential to managing arts organizations. These were so varied, so intertwined and interrelated, and they covered such a wide spectrum of human activities that just to list them became a problem.

The student would have to know the economics of a not-for-profit organization; the legal problems involved in organizing, conducting and supporting such an entity; the special industrial and labor relations issues and elements in an art organization; the relationship of art to society, to social issues, to minority groups, to the particular community in which it is located; as well as the special role which government at all levels can and does have with artistic bodies. In short, we would have to teach law, labor relations, sociology, government, public administration, taxation, aesthetics, and even the politics and history of our country and its multi-faceted society.

This was a tall order for the faculty of the Management School to meet, even though we had the participation of faculty members of the College of Fine Arts and the School of Law at UCLA. There were few, if any, people trained to teach these subjects within the context of arts management. Gradually such a group has developed and is beginning to meet the needs of a growing number of students training to become arts managers.

However, there was another equally serious problem. This was the relative absence of textbooks, research material, readings, data, statistics, analytical documentation, theoretical formulations and the like. This was not only true in the specifics of each of the areas just mentioned, but also in the interrelationship of each of the areas to the other--a very crucial element in the development of curricula and the teaching of students.

x

We in our Management in the Arts Program
were thus extremely fortunate in having Charlotte
Georgi as the Chief Librarian of the Graduate School
of Management Library. From the very beginning
Miss Georgi devoted her talents and knowledge to
helping us solve this fundamental need of our program.
Some preliminary work on our part indicated the tre-
mendous task which we faced in seeking out what was
already published, what was buried within past publica-
tions, in newspapers, magazines, trade journals,
government and private reports. Miss Georgi combed
the existing bibliographies, which were few in number,
to see what was still relevant, obtainable or available.
We cooperated on the task of getting reading lists of
seminars, workshops, conferences, and of some widely
scattered courses given in varied institutions and
schools, though these were generally limited to but one
area such as museums or symphony orchestras, where-
as our program was training managers for dance com-
panies, regional theater groups, arts councils and
similar organizations which therefore required that the
student learn the principles and techniques applicable
to all these fields rather than one.

This was a formidable task. It was compounded
by the myriad number of arts organizations flourishing
in the U.S. and the fact that arts councils at the fed-
eral, state, county and municipal levels were springing
up as quickly as fresh grass after a heavy rainfall.

What Charlotte Georgi has done is to help the
process of analysis of the components of the field of
Arts Management. Her bibliography is analogous to
the cartography of an uncharted and newly discovered
land It is a guide to the practitioner, the lawyer, the
administrator, the accountant, a member of the board
of directors, a trustee of a foundation, a government
official, a corporation executive, a layman in the arts,
and the citizen interested in the quality of life and art
in the U.S. It enables these persons and many others
to begin to see the role and function of art and arts
institutions in our society, to learn the beginnings, the
present problems and the directions of future trends.

Charlotte Georgi's work thus is an education in itself
for those seeking guidance and information; it directs
them to what is available in print today and what yet
remains to be written, thought about and researched
in the future. The knowledge contained in this volume
and obtained by reading the reference material will, I
am sure, become the beginning of wisdom for the many
who will read it, learn from it and use it as a founda-
tion and guide to future knowledge.

For this, and for her helpfulness, guidance and
patience, I am deeply grateful, as are all of us in-
volved in the Arts Management Program at UCLA. We
now are aware of what is available to us. We and
the others who will follow us, whether teachers, stu-
dents, researchers or concerned citizens, can now be-
gin the task of supplementing and adding to Charlotte
Georgi's work.

<div align="right">

HYMAN R. FAINE
Professor, Management
in the Arts Program

</div>

Graduate School of Management
University of California Los Angeles

I. BUSINESS, ECONOMICS, AND THE ARTS

Adizes, Ichak. Administering for the Arts--Problems in Practice. Los Angeles: Graduate School of Management, University of California, 1971. Management in the Arts Research Papers no. 15.

_____. UCLA Conferences on Arts Administration: Summary of the Meetings and a Report on Implementation. Los Angeles: Graduate School of Management, University of California, 1969. 34p. Management in the Arts Research Papers no. 1.

_____. The Unique Character of Performing Arts Organizations and the Functioning of Their Boards of Directors (a Managerial Analysis). Los Angeles: Graduate School of Management, University of California, 1971. 14p. Management in the Arts Research Papers no. 4.

Artist and Advocate; an Essay on Corporate Patronage. Edited by Nina Kaiden and Bartlett Hayes. New York: Renaissance Editions, 1967. 93p.

Arts Council of Great Britain. Training Arts Administrators. Report of the Committee on Enquiry into Arts Administration Training. London: Arts Council of Great Britain, 1971. 76p.

Business in the Arts '70. Gideon Chagy, editor. New York: Paul S. Eriksson, 1970. 176p.

Eells, Richard Sedric Fox. The Corporation and the Arts. New York: Macmillan, 1967. 365p.

Galbraith, John Kenneth. The Liberal Hour. Boston:

13

Houghton Mifflin, 1960. 197p. See Essay III,
"Economics and Art."

_____. The New Industrial State. Second edition,
revised. Boston: Houghton Mifflin, 1971. 423p.

Gingrich, Arnold. Business & the Arts; an Answer to
Tomorrow. Foreword by David Rockefeller. New
York: Paul Eriksson, 1969. 141p.

Henle, Guenter. Three Spheres; a Life in Politics,
Business and Music, the Autobiography of Guenter
Henle. Chicago: Henry Regnery, 1971. 277p.

Pfeffer, Irving. Fine Arts: a Program in Risk Man-
agement. Los Angeles: Graduate School of
Management, University of California, 1971. 34p.
Management in the Arts Research Papers no. 7.

Purtell, Joseph. The Tiffany Touch. New York:
Random House, 1971. 309p.

Raymond, Thomas C. Cases in Arts Administration.
By Thomas C. Raymond, Stephen A. Greyser
and Douglas Schwalbe with the assistance of
Carol M. Cross. Cambridge, Massachusetts:
Institute of Arts Administration, 1971. various
pagings.

Reichardt, Jasia. Cybernetic Serendipity; the Com-
puter and the Arts. New York: Praeger, 1969,
c1968. 101p. Special issue, August 1968,
Studio International.

_____, compiler. Cybernetics, Art and Ideas.
Greenwich, Connecticut: New York Graphic
Society, 1971. 207p.

Reiss, Alvin H. The Arts Management Handbook; a
Guide for Those Interested in or Involved with
the Administration of Cultural Institutions. Pref-
ace by John H. MacFadyen. New York: Law-
Arts, 1970. 655p.

Reitlinger, Gerald. The Economics of Taste; the Rise
and Fall of Picture Prices, 1760-1960. New
York: Holt, Rinehart and Winston, 1964. (Bar-
rie and Rockliff, London, 1961.) 518p.

_____ . The Economics of Taste; the Rise and Fall
of the Objets d'Art Market Since 1750. New
York: Holt, Rinehart and Winston, 1965. (Bar-
rie and Rockliff, London, 1963.) 714p.

Rodewald, Fred C. Commercial Art as a Business.
By Fred Rodewald and Edward Gottschall. Second
revised edition. New York: Viking, 1971. 173p.

Rush, Richard H. Art as an Investment. Englewood
Cliffs, New Jersey: Prentice-Hall, 1961. 418p.

Russell-Cobb, Trevor. Paying the Piper: the Theory
and Practice of Industrial Patronage. London:
Queen Anne Press, 1968. 111p.

Smith, George Alan. Arts Administrator Need and
Potential in New York State; a Study for the
New York State Council on the Arts. Albany,
New York: 1968. 40p.

The State of the Arts and Corporate Support. Gideon
Chagy, editor. New York: Paul S. Eriksson,
1971. 184p.

II. CULTURE, LEISURE, AND THE ARTS

Anderson, Nels. Work and Leisure. New York:
 Free Press of Glencoe, 1961. 265p.

The Arts on Campus: the Necessity for Change. By
 James Ackerman et al. Edited by Margaret
 Mahoney with the assistance of Isabel Moore.
 Greenwich, Connecticut: New York Graphic
 Society, 1970. 143p.

Charlesworth, James Clyde, editor. Leisure in
 America: Blessing or Curse? Philadelphia:
 American Academy of Political and Social Sci-
 ence, 1964. 96p.

Clapp, Jane. Art Censorship: a Chronology of Pro-
 scribed and Prescribed Art. Metuchen, New
 Jersey: Scarecrow Press, 1972. 582p.

The Cultural Arts; Conference Number 2, University
 of California, Los Angeles, April 5-7, 1963.
 Abbott Kaplan, conference chairman. Berkeley:
 University of California, 1964. 214p.

DeGrazia, Sebastian. Of Time, Work and Leisure.
 New York: Twentieth Century Fund, 1962. 559p.

Denney, Reuel. The Astonished Muse. Chicago:
 University of Chicago Press, 1957. 264p.

Dorian, Frederick. Commitment to Culture; Art
 Patronage in Europe, Its Significance for America.
 Pittsburgh: University of Pittsburgh Press, 1964.
 521p.

Dumazedier, Joffre. Toward a Society of Leisure.
 Translated from the French by Stewart E. Mc-
 Clure. New York: Free Press, 1967. 307p.

Fisk, George. Leisure Spending-Behavior. Philadel-
 phia: University of Pennsylvania Press, 1963.
 202p.

Hall, James B. Modern Culture and the Arts. By
 James B. Hall and Barry Ulanov. Second edi-
 tion. New York: McGraw-Hill, 1972. 574p.

Heckscher, August. The Public Happiness. New York:
 Atheneum, 1962. 304p.

Kaplan, Max. Leisure in America: a Social Inquiry.
 New York: Wiley, 1960. 350p.

Larrabee, Eric, editor. Mass Leisure. Edited by
 Eric Larrabee and Rolf Meyersohn. Glencoe,
 Illinois: Free Press, 1958. 429p.

Linder, Steffan B. The Harried Leisure Class. New
 York: Columbia University Press, 1970. 182p.

McLuhan, Herbert Marshall. Culture Is Our Business.
 New York: McGraw-Hill, 1970. 336p.

McMullen, Roy. Art, Affluence, and Alienation; the
 Fine Arts Today. New York: Praeger, 1968.
 272p.

Mark, Charles C. A Study of Cultural Policy in the
 United States. Paris: United Nations Educational,
 Scientific and Cultural Organization, 1969. 43p.
 Studies and Documents on Cultural Policies no. 2.

Miller, Lillian B. Patrons and Patriotism; the En-
 couragement of the Fine Arts in the United States,
 1790-1860. Chicago: University of Chicago
 Press, 1966. 335p.

Miller, Norman P. The Leisure Age: Its Challenge

to Recreation. Belmont, California: Wadsworth
Publishing Company, 1963. 497p.

Newton, Michael. Persuade and Provide; the Story of
the Arts and Education Council in St. Louis. By
Michael Newton and Scott Hatley. With an intro-
duction by Nancy Hanks. New York: Associated
Councils of the Arts, 1970. 249p.

On the Future of Art. By Arnold J. Toynbee et al.
Introduction by Edward F. Fry. New York: Vi-
king, 1970. 134p.

Owen, John D. The Price of Leisure. An Economic
Analysis of the Demand for Leisure Time. Rot-
terdam: Rotterdam University Press, 1969. 169p.

Parker, Stanley. The Future of Work and Leisure.
New York: Praeger, 1971. 160p.

Pieper, Josef. Leisure, the Basis of Culture. Trans-
lated from the German by Alexander Dru. With
an introduction by T. S. Eliot. Revised edition.
New York: Pantheon, 1964. 130p.

Reiss, Alvin H. Culture and Company: a Critical
Study of an Improbable Alliance. New York:
Twayne, 1972.

Riesman, David. Abundance for What? and Other Es-
says. Garden City, New York: Doubleday, 1964.
610p.

_____. The Lonely Crowd; a Study of the Changing
American Character. By David Riesman in col-
laboration with Reuel Denney and Nathan Glazer.
New Haven, Connecticut: Yale University Press,
1962, c1950. 386p.

Rosenberg, Bernard, editor. Mass Culture; the Pop-
ular Arts in America. Edited by Bernard Rosen-
berg and David Manning White. Glencoe, Illinois:
Free Press, 1957. 561p.

Simon, Yves René Marie. Work, Society, and Culture. Edited by Vukan Kuic. Bronx, New York: Fordham University Press, 1971. 234p.

Smigel, Erwin Olson. Work and Leisure; a Contemporary Social Problem. New Haven, Connecticut: College and University Press, 1963. 208p.

Technology and Culture: an Anthology. Edited by Melvin Krandberg and William H. Davenport. New York: Schocken, 1972.

Technology, Human Values, and Leisure. Edited by Max Kaplan and Phillip Bosserman. Nashville, Tennessee: Abingdon Press, 1971. 256p.

Toffler, Alvin. The Culture Consumers; a Study of Art and Affluence in America. New York: St. Martin's Press, 1964. 263p.

Veblen, Thorstein. The Theory of the Leisure Class. Introduction by Robert Lekachman. New York: Viking, 1967. 400p.

Webber, Ross A., compiler. Culture and Management; Text and Readings in Comparative Management. Homewood, Illinois: Richard D. Irwin, 1969. 598p.

III. FOUNDATIONS, GRANTS, AND FUND-RAISING

Annual Register of Grant Support. Los Angeles: Aca-
 demic Media, Inc., 1971. 419p.

Carr, Elliott G. Better Management of Business Giv-
 ing. Foreword by John H. Watson III. New
 York: Hobbs, Dorman, 1966. 114p.

Carter, Paul C. Handbook of Successful Fund-Raising.
 New York: Hawthorn, 1970. various pagings.

Commerce Clearing House. The Private Foundation
 and the Tax Reform Act. Chicago: Commerce
 Clearing House, 1970. 157p.

Commission on Foundations and Private Philanthropy.
 Foundations, Public Giving, and Public Policy;
 Report and Recommendations. Chicago: Univer-
 sity of Chicago Press, 1970. 287p.

Dickinson, Frank G. The Changing Position of Philan-
 thropy in the American Economy. New York:
 National Bureau of Economic Research, Columbia
 University Press, 1970. 222p.

Flexner, Abraham. Funds and Foundations; Their Pol-
 icies, Past and Present. New York: Harper
 and Row, 1952. 146p.

The Ford Foundation. Annual Report. October 1,
 1970 to September 30, 1971. 112p.

Foundation Directory. Marianna O. Lewis, editor.
 Fourth edition. New York: Columbia University
 Press, 1971. 642p.

Goulden, Joseph C. The Money Givers. New York: Random House, 1971. 341p.

Grants and Aid to Individuals in the Arts. Washington, D.C.: Washington International Arts Letter, 1970. 76p.

The Grants Register, 1971-73. Chicago: St. James Press, 1970. 553p.

Hanson, Abel A. Guides to Successful Fund Raising. New York: Teachers College Press, Columbia University, 1961. 54p.

Hunter, Thomas Willard. The Tax Climate for Philanthropy. Washington, D.C.: American College Public Relations Association, 1968. 207p.

Institute of International Education. International Awards in the Arts; for Graduate and Professional Study. New York: Institute of International Education, 1969. 105p.

Millions for the Arts: Federal and State Cultural Programs. Washington, D.C.: Washington International Arts Letter, 1972. 64p.

National Council on the Arts. National Endowment for the Arts. The First Five Years: Fiscal 1966 through Fiscal 1970. Washington, D.C.: National Council on the Arts. various pagings.

Nelson, Ralph L. The Investment Policies of Foundations. New York: Russell Sage Foundation, 1967. 203p.

Private Foundations Active in the Arts. Washington, D.C.: Washington International Arts Letter, 1970. 138p. Arts Patronage Series v. 1. (Basic volume plus supplementary pamphlets issued from time to time.)

Reeves, Thomas C., compiler. Foundations Under

Fire. Ithaca, New York: Cornell University
Press, 1970. 235p.

Rudy, William H. The Foundations, Their Use and
Abuse. Washington, D.C.: Public Affairs Press,
1970. 75p.

Washington and the Arts; a Guide and Directory to Fed-
eral Programs and Dollars for the Arts. Janet
English Gracey and Sally Gardner, special editors.
New York: Associated Councils of the Arts, 1971.
176p.

White, Stephen. Evaluation of Foundation Activities.
New York: Alfred P. Sloan Foundation, 1970.
15p.

Young, Donald R. Trusteeship and the Management of
Foundations. By Donald R. Young and Wilbert
E. Moore. New York: Russell Sage Foundation,
1969. 158p.

NOTE: For information about financial support for edu-
cational projects in architecture, art education,
art history, cinematography, dance, design,
graphic arts, museology, music, painting, ra-
dio and television, sculpture, and theater arts,
see International Awards in the Arts; for Grad-
uate and Professional Study, issued by the In-
stitute of International Education, and the
pamphlet, Grants and Aid to Individuals in the
Arts.

These list scholarships, fellowships, and as-
sistantships available at specific institutions,
travel awards, grants for special projects, etc.
The latter title has no subject approach (ex-
cept code references to eligible fields) and
gives minimal, often cryptic, information. It
does, however, list musical competitions
which might otherwise remain undiscovered.

Among general reference aids, The Grants
Register and the Annual Register of Grant Sup-
port have detailed subject indexes which afford
easy access to appropriate listings. Despite
considerable overlapping, none of these titles
is complete. Each contains entries listed no-
where else.

IV. GOVERNMENT AND THE ARTS

Adams, William H. The Politics of Art; Forming a
State Arts Council. New York: Arts Councils
of America, 1966. 49p.

Arts Council of Great Britain. Twenty-sixth Annual
Report and Accounts, Year Ended 31 March 1971.
London: Arts Council of Great Britain, 1971.
80p., A77p.

Burgard, Ralph. Arts in the City; Organizing and Pro-
gramming Community Arts Councils. New York:
Associated Councils of the Arts, 1968. 150p.

California. Arts Commission. The Arts in California;
a Report to the Governor and the Legislature on
the Cultural and Artistic Resources of the State
of California. Sacramento: California Arts Com-
mission, 1966. 86p.

Emery, Walter Byron. Broadcasting and Government;
Responsibilities and Regulations. Revised edition.
East Lansing: Michigan State University, 1971.
569p.

Harris, John S. Government Patronage of the Arts in
Great Britain. Chicago: University of Chicago
Press, 1970. 341p.

Illinois. Advisory Commission on Financing the Arts
in Illinois. Report. Chicago: Advisory Com-
mission on Financing the Arts in Illinois, 1971.
127p.

McDonald, William Francis. Federal Relief Adminis-
tration and the Arts; the Origins and Administra-

24

tive History of the Works Project Administration.
Columbus: Ohio University Press, 1969. 869p.

National Council on the Arts. National Endowment for
the Arts. The First Five Years: Fiscal 1966
Through Fiscal 1970. Washington, D.C.: Na-
tional Council on the Arts. various pagings.

National Endowment for the Arts. Programs of the
National Council on the Arts and the National En-
dowment for the Arts. Washington, D.C.: Budg-
et and Research Division, National Endowment for
the Arts, 1971. various pagings.

_____ . Office of Research. Federal Funds and
Services for the Arts. Compiled by Judith G.
Gault. Washington, D.C.: Office of Education,
U.S. Department of Health, Education and Wel-
fare; for sale by the Superintendent of Documents,
U.S. Government Printing Office, 1967.

National Endowment for the Humanities. Report, 1970/
71. Washington, D.C.: National Endowment for
the Humanities, 1972. 86p.

New York (State). State Council on the Arts. New
York State Council on the Arts; Report, 1969/70.
New York: State Council on the Arts, 1970.
135p.

O'Connor, Francis V. Federal Support for the Visual
Arts: the New Deal and Now; a Report on the
New Deal Art Projects in New York City and
State with Recommendations for Present-day Fed-
eral Support for the Visual Arts to the National
Endowment for the Arts. Greenwich, Connecticut:
New York Graphic Society, 1969. 226p.

_____ , editor. The New Deal Art Projects: an
Anthology of Memoirs. Washington, D.C.:
Smithsonian Institution Press, 1972. 339p.

Popenoe, David, compiler. The Urban-Industrial Fron-
 tier; Essays on Social Trends and Industrial Goals
 in Modern Communities. New Brunswick, New
 Jersey: Rutgers University, 1969. 176p. See
 chapter, "Government, the Arts, and the City,"
 by August Heckscher.

Purcell, Ralph. Government and Art, a Study of Amer-
 ican Experience. With an introduction by Clarence
 Derwent. Washington, D.C.: Public Affairs
 Press, 1956. 129p.

Robbins, Lionel Charles, baron. Politics and Econom-
 ics; Papers on Political Economy. New York:
 St. Martin's Press, 1963. 230p. See chapter,
 "Art and the State."

Scott, Mellier Goodin. Partnership in the Arts; Public
 and Private Support of Cultural Activities in the
 San Francisco Bay Area. Berkeley: Institute of
 Governmental Studies, University of California,
 1963. 55p.

 _____. The States and the Arts; the California Arts
 Commission and the Emerging Federal-State Part-
 nership. Berkeley: Institute of Governmental
 Studies, University of California, 1971. 129p.

State Financial Assistance to Cultural Resources; Re-
 port of the New York State Commission on Cul-
 tural Resources. New York: State Commission
 on Cultural Resources, 1971. 163p.

U.S. Congress. House. Select Committee on Small
 Business. Tax-Exempt Foundations and Charitable
 Trusts. Subcommittee Chairman's Reports, Six
 Installments: Dec. 31, 1962; March 20, 1964;
 Dec. 1, 1966; April 28, 1967; and March 25,
 1968. Washington, D.C.: U.S. Government
 Printing Office, 1962-68. [Reports of the inves-
 tigations conducted by Subcommittee No. 1, Select
 Committee on Small Business, U.S. House of
 Representatives, Wright Patman, Chairman.]

U. S. Library of Congress. Congressional Research
 Service. Survey of United States and Foreign
 Government Support for Cultural Activities. Wash-
 ington, D. C.: U. S. Government Printing Office,
 1971. 245p.

U. S. Office of Education. Support for the Arts and
 Humanities. Washington, D. C.: U. S. Govern-
 ment Printing Office, 1972. 22p.

Washington and the Arts; a Guide and Directory to
 Federal Programs and Dollars for the Arts.
 Janet English Gracey and Sally Gardner, special
 editors. New York: Associated Councils of the
 Arts, 1971. 176p.

V. LABOR UNIONS AND THE ARTS

Bernstein, Irving. The Economics of Television Film
 Production and Distribution; a Report to Screen
 Actors Guild, February 8, 1960. Sherman Oaks,
 California: 1960. 132p.

 _____. Hollywood at the Crossroads; an Economic
 Study of the Motion Picture Industry, Especially
 Prepared for the Hollywood A F of L Film Coun-
 cil. Hollywood, California: 1957. 78p.

Broadcasting and Bargaining; Labor Relations in Radio
 and Television. Edited by Allen E. Koenig.
 Madison: University of Wisconsin Press, 1970.
 334p.

Cauble, John R. A Study of the International Alliance
 of Theatrical Stage Employees and Moving Picture
 Machine Operators of the United States and Can-
 ada. Los Angeles: 1964. 153p. UCLA Mas-
 ter's Thesis.

Faine, Hyman R. Unions and the Arts. Los Angeles:
 Graduate School of Management, University of
 California, 1972. 17p. Management in the Arts
 Research Papers no. 11.

Harvey, Michael Lance. The Actors Equity Associa-
 tion-League of New York Theaters Contract Dis-
 pute of 1960; a Descriptive Study. Los Angeles:
 1963. 131p. UCLA Master's Thesis.

Kleingartner, Archie. A Note on Labor-Management
 Relations in the Performing Arts: the Case of
 Los Angeles. By Archie Kleingartner and Ken-
 neth Lloyd. Los Angeles: Graduate School of

Management, University of California, 1971.
12p. Management in the Arts Research Papers
no. 16.

Lloyd, Kenneth. Adherence to Work Rules: a Case
Study of the Professional Theatrical Actor in the
Los Angeles Area. Los Angeles: 1972. 246p.
UCLA Ph. D. Dissertation.

_____. Union-Management Relations in the Arts
Enterprise Industry: an Applied Cross-Sector
Analysis. Los Angeles: Graduate School of
Management, University of California, 1970.
53p. Unpublished research paper.

Moskow, Michael H. Labor Relations in the Perform-
ing Arts; an Introductory Survey. Foreword by
John T. Dunlop. New York: Associated Coun-
cils of the Arts, 1969. 218p.

Perry, Louis B. A History of the Los Angeles Labor
Movement, 1911-1941. By Louis B. Perry and
Richard S. Perry. Berkeley: University of
California Press, 1963. 622p.

Refior, Everett Lee. The American Federation of
Musicians: Organization, Policies, and Prac-
tices. Chicago: 1955. University of Chicago
Master's Thesis.

Screen Actors Guild. The Story of the Screen Actors
Guild. Hollywood, California: Public Relations
Department, Screen Actors Guild, 1966. 23p.

Stoyle, Judith. Economic and Demographic Character-
istics of Actors' Equity Association Membership.
Philadelphia: Actors' Equity Association in co-
operation with Bureau of Economic and Business
Research, School of Business Administration,
Temple University of the Commonwealth System
of Higher Education, 1970.

U. S. Bureau of Labor Statistics. Directory of National and International Labor Unions in the United States, 1969. Washington, D. C.: U. S. Government Printing Office, 1969. 121p.

Wertheimer, Barbara M. Exploring the Arts; a Handbook for Trade Union Program Planners. New York: New York State School of Industrial and Labor Relations, Cornell University, Division of Extension and Public Service, 1968. 61p.

VI. LEGAL ASPECTS OF THE ARTS

American Symphony Orchestra League. Study Commit-
 tee. Study of Legal Documents of Symphony Or-
 chestras. Charleston, West Virginia: American
 Symphony Orchestra League, 1958. 61p.

Associated Councils of the Arts. The Visual Artist
 and the Law. New York: Associated Councils
 of the Arts, 1971. 100p.

Berk, Lee Eliot. Legal Protection for the Creative
 Musician. Boston: Berklee Press, 1970. 371p.

Beverly Hills Bar Association. Program on Legal As-
 pects of the Entertainment Industry. Co-sponsored
 with the University of Southern California Law
 Center. Los Angeles: Beverly Hills Bar Asso-
 ciation, 1958-to date. Annual publication.

 The following volumes are recommended especial-
 ly:
 5. Syllabus and forms on American motion pic-
 ture production in foreign countries;
 6. Syllabus and forms on I. Selected problems
 in theatrical and television film distribution
 agreements. II. Income tax aspects of the
 joint venture;
 7. Syllabus and forms on the new collective bar-
 gaining agreements;
 8. Syllabus and forms on acquiring and using
 music;
 9. Syllabus and forms on producing and financing
 dramatic and musical plays and acquiring mo-
 tion picture rights in plays;
 10. Syllabus and forms on torts and taxes;
 11. Television film production and distribution;

13. Current industry developments. Topic:
artists' managers, personal managers, and
business managers: their functions in the en-
tertainment field;
14. Production money (where the money is and
what the money gets).

Cahn, Joshua Benion. Copyright in Works of Art.
Second edition. New York: Artists Equity Asso-
ciation, 1956. 15p.

California. University, Los Angeles. School of Law.
Library. Holdings in Copyright Law, to March
11, 1963. Los Angeles: Library, School of Law,
University of California, 1963. 35 l.

_____ . Holdings in Legal Aspects of the Entertain-
ment Industry and Peripheral Materials. Los
Angeles: Library, School of Law, University of
California, 1963. 15p.

Carmen, Ira R. Movies, Censorship, and the Law.
Ann Arbor: University of Michigan Press, 1966.
399p.

DeGrazia, Edward. Censorship Landmarks. New York:
R. R. Bowker, 1969. 657p.

Federal Bar Association of New York, New Jersey and
Connecticut. Committee on the Law of the The-
atre. The Business and Law of Music; a Sympo-
sium. Edited by Joseph Taubman. New York:
Federal Legal Publications, 1965. 111p.

_____ . Financing a Theatrical Production; a Sympo-
sium. Edited by Joseph Taubman. New York:
Federal Legal Publications, 1964. 499p.

Index to Legal Periodicals. New York: H. W. Wilson
Company. Monthly, October-August; annual and
three year cumulations. An author and subject
index to legal periodicals and journals.

Intergovernmental Conference on Copyright, Geneva,
 1952. The Law of Copyright Under the Universal
 Convention. By Arpad Bogsch. Leyden: A. W.
 Sijthoff; New York: R. R. Bowker, 1964. 591p.

Lindey, Alexander. Entertainment, Publishing and the
 Arts--Agreements and the Law. New York:
 Clark Boardman, 1963-. (Biennial supplements.)
 2 v., looseleaf. ⊬2000p.

Los Angeles Copyright Society. Copyright and Related
 Topics; a Choice of Articles. Edited by the Los
 Angeles Copyright Society and the UCLA School
 of Law. Berkeley: University of California
 Press, 1964. 609p.

McClellan, Grant S., compiler. Censorship in the
 United States. New York: H. W. Wilson Com-
 pany, 1967. 222p. The Reference Shelf, v. 39,
 no. 3.

Moon, Eric, editor. Book Selection and Censorship in
 the Sixties. New York: R. R. Bowker, 1969.
 421p.

Nimmer, Melville B. Nimmer on Copyright; a Treatise
 on the Law of Literary, Musical and Artistic
 Property, and the Protection of Ideas. Albany,
 New York: Mathew Bender, 1963-. looseleaf.

Pilpel, Harriet F. A Copyright Guide. By Harriet F.
 Pilpel and Morton David Goldberg. Fourth edi-
 tion. New York: R. R. Bowker, 1969. 40p.

Pinner, H. L., editor. World Copyright, an Encyclo-
 pedia. Leyden: A. W. Sijthoff, 1953-60. 5 v.
 (The Protection of Intellectual and Industrial Prop-
 erty Throughout the World, a Legal Encyclopedia.)

Price, Monroe E. Government Policy and Economic
 Security for Artists: the Case of the "Droit de
 Suite." Los Angeles: 1970. 70p.

Randall, Richard S. Censorship of the Movies; the
 Social and Political Control of a Mass Medium.
 Madison: University of Wisconsin Press, 1968.
 280p.

Rothenberg, Stanley. Legal Protection of Literature,
 Art and Music. New York: Clark Boardman,
 1960. 367p.

Smith, Cecil M. Worlds of Music. Philadelphia:
 J.B. Lippincott, 1952. 328p.

Spiegel, Irwin O. Record and Music Publishing Forms
 of Agreement in Current Use. Compiled and
 edited by Irwin O. Spiegel and Jay L. Cooper.
 New York: Law-Arts, 1971. 859p. looseleaf.

Taubman, Joseph. Performing Arts Management and
 Law. New York: Law-Arts, 1972.

Walls, Howard Lamarr. The Copyright Handbook for
 Fine and Applied Arts. New York: Watson-
 Guptill Publications, 1963. 125p.

Whicher, John F. The Creative Arts and the Judicial
 Process; Four Variations on a Legal Theme.
 New York: Federal Legal Publications, 1965.
 252p.

VII. MANAGEMENT IN THE ARTS RESEARCH PAPERS

NOTE: This series is published by the Management in the Arts Program, Graduate School of Management/Division of Research, University of California, Los Angeles.

1. Adizes, Ichak. UCLA Conferences on Arts Administration: Summary of the Meetings and a Report on Implementation. Los Angeles: Graduate School of Management, University of California, 1969. 34p.

2. Georgi, Charlotte. The Arts and the Art of Administration; a Selected Bibliography. Los Angeles: Graduate School of Management, University of California, 1970. 51p.

3. California Theater Index, 1971: College, University Facilities. Los Angeles: Graduate School of Management, University of California, 1971. 46p.

4. Adizes, Ichak. The Unique Character of Performing Arts Organizations and the Functioning of Their Boards of Directors (a Managerial Analysis). Los Angeles: Graduate School of Management, University of California, 1971. 14p.

5. _____. Seattle Opera Association; a Policy Making Case for Management in the Arts. Los Angeles: Graduate School of Management, University of California, 1971. 53p.

6. Goodman, Richard Alan. An Exploration into the

Administrative Support of the Creative Proc-
ess: the Theater Case. By Richard Alan
Goodman and Mirta Samuelson. Los An-
geles: Graduate School of Management,
University of California, 1970. 13p.

7. Pfeffer, Irving. Fine Arts: a Program in Risk
Management. Los Angeles: Graduate
School of Management, University of Cali-
fornia, 1971. 34p.

8. Granfield, Michael. The Live Performing Arts:
Financial Catastrophe or Economic Cathar-
sis. Los Angeles: Graduate School of
Management, University of California, 1971.
23p.

9. Adizes, Ichak. Arts, Society and Administration:
the Role and Training of Arts Administra-
tors. By Ichak Adizes and William Mc-
Whinney. Los Angeles: Graduate School
of Management, University of California,
1971. 16p.

10. Blaine, Martha. The Parkview Symphony: Cases
A and B. Los Angeles: Graduate School
of Management, University of California,
1971. 20p.

11. Faine, Hyman R. Unions and the Arts. Los
Angeles: Graduate School of Management,
University of California, 1972. 17p.

12. Garrison, Lee C. The Composition, Attendance
Behavior and Needs of Motion Picture Au-
diences: a Review of the Literature. Los
Angeles: Graduate School of Management,
University of California, 1971. 36p.

13. _____. Comparative Profiles of Users and
Nonusers of the Los Angeles Music Center.
By Lee C. Garrison and Christina Vogl
Kaali-Nagy. Los Angeles: Graduate School

of Management, University of California,
1971. 38p.

14. Goodman, Richard Alan. Theatre as a Tempo-
 rary System. By Richard Alan Goodman
 and Lawrence Peter Goodman. Los An-
 geles: Graduate School of Management,
 University of California, 1971. 15p.

15. Adizes, Ichak. Administering for the Arts --
 Problems in Practice. Los Angeles:
 Graduate School of Management, University
 of California, 1971.

16. Kleingartner, Archie. A Note on Labor-Manage-
 ment Relations in the Performing Arts:
 the Case of Los Angeles. By Archie Klein-
 gartner and Kenneth Lloyd. Los Angeles:
 Graduate School of Management, University
 of California, 1971. 12p.

VIII. THE MASS MEDIA:
RADIO, TELEVISION, AND FILMS

Bernstein, Irving. The Economics of Television Film
Production and Distribution; a Report to Screen
Actors Guild, February 8, 1960. Sherman Oaks,
California: 1960. 132p.

_____. Hollywood at the Crossroads; an Economic
Study of the Motion Picture Industry, Especially
Prepared for the Hollywood A F of L Film Coun-
cil. Hollywood, California: 1957. 78p.

Beverly Hills Bar Association. Program on Legal As-
pects of the Entertainment Industry. Co-sponsored
with the University of Southern California Law
Center. Los Angeles: 1958-to date. Annual pub-
lication. (See Part VI, LEGAL ASPECTS OF
THE ARTS, for explanatory note.)

Bluem, A. William. The Movie Business; American
Film Industry Practice. Edited by A. William
Bluem and Jason E. Squire. New York: Hast-
ings House, 1972. 368p.

Blum, Eleanor. Basic Books in the Mass Media; an
Annotated, Selected Booklist Covering General
Communications, Book Publishing, Broadcasting,
Film, Magazines, Newspapers, Advertising, In-
dexes, and Scholarly and Professional Periodicals.
Urbana: University of Illinois, 1972. 252p.

Bogart, Leo. The Age of Television; a Study of View-
ing Habits and the Impact of Television on Amer-
ican Life. Third edition. New York: Frederick
Ungar Publishing Company, 1971. 515p.

38

Broadcasting and Bargaining; Labor Relations in Radio
 and Television. Edited by Allen E. Koenig.
 Madison: University of Wisconsin, 1970. 344p.

Brown, Les. Television; the Business Behind the Box.
 New York: Harcourt, Brace, Jovanovich, 1971.
 374p.

Brown, William O. Low Budget Features. Hollywood,
 California: author, 1971. 231p. (Dealer: Larry
 Edmunds, 6658 Hollywood Blvd.)

Cantor, Muriel G. The Hollywood TV Producer; His
 Work and His Audience. New York: Basic
 Books, 1971. 256p.

Carmen, Ira R. Movies, Censorship, and the Law.
 Ann Arbor: University of Michigan Press, 1966.
 399p.

Cauble, John R. A Study of the International Alliance
 of Theatrical Stage Employees and Moving Pic-
 ture Machine Operators of the United States and
 Canada. Los Angeles: 1964. 153p. UCLA
 Master's Thesis.

Cherington, Paul W. Television Station Ownership; a
 Case Study of Federal Agency Regulation. Edited
 by Paul W. Cherington, Leo V. Hirsch and Rob-
 ert Brandwein. New York: Hastings House, 1971.
 304p.

Coddington, Robert H. Modern Radio Broadcasting:
 Management & Operation in Small-to-Medium
 Markets. Blue Ridge Summit, Pennsylvania:
 G/L Tab Books, 1969. 256p.

Coleman, Howard W. Case Studies in Broadcast Man-
 agement. New York: Hastings House, 1970.
 95p.

Directors at Work; Interviews with American Film-
 Makers. Interviews conducted and edited by

Bernard R. Kantor, Irwin R. Blacker and Anne Kramer. New York: Funk and Wagnalls, 1970. 442p.

Emery, Walter Byron. Broadcasting and Government: Responsibilities and Regulations. Revised edition. East Lansing: Michigan State University, 1971. 569p.

Garrison, Lee C. The Composition, Attendance Behavior and Needs of Motion Picture Audiences: a Review of the Literature. Los Angeles: Graduate School of Management, University of California, 1971. 36p. Management in the Arts Research Papers no. 12.

Green, Timothy. The Universal Eye; the World of Television. New York: Stein and Day, 1972. 276p.

Guback, Thomas H. The International Film Industry; Western Europe and America Since 1945. Bloomington: Indiana University Press, 1969. 244p.

Head, Sydney W. Broadcasting in America. Second edition. Boston: Houghton Mifflin, 1972. 563p.

Hoffer, Jay. Managing Today's Radio Station. Blue Ridge Summit, Pennsylvania: G/L Tab Books, 1968. 288p.

_____. Organization & Operation of Broadcast Stations. Blue Ridge Summit, Pennsylvania: G/L Tab Books, 1971. 251p.

Johnson, Joseph Steve. Modern Radio Station Practices. By Joseph Steve Johnson and Kenneth K. Jones. Belmont, California: Wadsworth Publishing Company, 1972. 269p.

McMahan, Harry Wayne. Television Production; the Creative Techniques and Language of TV Today. New York: Hastings House, 1957. 231p.

Mayer, Martin. About Television. New York: Harper
 and Row, 1972. 434p.

Minus, Johnny. The Movie Industry Book; How Others
 Made and Lost Money in the Movie Industry. By
 Johnny Minus and William Storm Hale. Holly-
 wood, California: 7 Arts Press, 1970. 601p.

Parker, Ben R. Creative Intention. By Ben R. Parker
 and Pat J. Drabik. New York: Law-Arts, 1972.

Peck, William Allen. Anatomy of Local Radio-TV
 Copy. Third edition. Blue Ridge Summit, Penn-
 sylvania: G/L Tab Books, 1968. 93p.

_____. Radio Promotion Handbook. Blue Ridge
 Summit, Pennsylvania: G/L Tab Books, 1968.
 191p.

Peterson, Theodore Bernard. The Mass Media and
 Modern Society. By Theodore Bernard Peterson
 and Jay W. Jensen. New York: Holt, Rinehart
 and Winston, 1965. 259p.

Phillips, Mary Alice Mayer. CATV: a History of
 Community Antenna Television. Evanston, Illi-
 nois: Northwestern University Press, 1972.
 209p.

Price, Monroe E. Cable Television: a Guide for
 Citizen Action. By Monroe E. Price and John
 Wicklein. Foreword by Everett C. Parker.
 Philadelphia: Pilgrim Press, 1972. 160p.

Quaal, Ward L. Broadcast Management: Radio, Tele-
 vision. By Ward L. Quaal and Leo A. Martin.
 New York: Hastings House, 1968. 251p.

Randall, Richard S. Censorship of the Movies; the
 Social and Political Control of a Mass Medium.
 Madison: University of Wisconsin Press, 1968.
 280p.

Rissover, Fredric. Mass Media and the Popular Arts.
By Fredric Rissover and David C. Birch. New
York: McGraw-Hill, 1971. 348p.

Roe, Yale, editor. Television Station Management;
the Business of Broadcasting. New York: Hast-
ings House, 1964. 251p.

Routt, Edd. The Business of Radio Broadcasting.
Blue Ridge Summit, Pennsylvania: G/L Tab
Books, 1972. 400p.

Screen Actors Guild. The Story of the Screen Actors
Guild. Hollywood, California: Public Relations
Department, Screen Actors Guild, 1966. 23p.

Sitney, P. Adams, editor. Film Culture Reader. New
York: Praeger, 1970. 438p.

Smith, David R. Jack Benny Checklist: Radio, Tele-
vision, Motion Pictures, Books and Articles.
Los Angeles: University of California Library,
1970. 33p.

Steinberg, Charles S. The Communicative Arts: an
Introduction to Mass Media. New York: Hastings
House, 1970. 371p.

Steiner, Gary Albert. The People Look at Television;
a Study of Audience Attitudes. New York: Al-
fred Knopf, 1963. 422p.

Stormes, John M. Television Communications Systems
for Business and Industry. By John M. Stormes
and James P. Crumpler. New York: Wiley-
Interscience, 1970. 238p.

Tyrrell, R. W. The Work of the Television Journalist.
London: Focal Press, 1972. 176p.

Wainwright, Charles Anthony. Television Commer-
cials; How to Create Successful TV Advertising.
Revised edition. New York: Hastings House,
1970. 318p.

IX. MUSEUM MANAGEMENT AND THE ARTS

Allan, Douglas Alexander. Administration. By D. A.
 Allan, D. E. Owen, and F. S. Wallis. London:
 The Museums Association, 1960. 51p. Hand-
 book for Museum Curators, Part A, Section 1.

American Association of Museums. America's Muse-
 ums; the Belmont Report. Washington, D. C.:
 American Association of Museums, 1968. 81p.

_____. Museum Training Courses in the United
 States and Canada. Revised edition. Washington,
 D. C.: American Association of Museums, 1971.
 51p.

_____. 1971 Financial and Salary Survey. Wash-
 ington, D. C.: American Association of Museums,
 1971. 92p.

_____. A Statistical Survey of Museums in the
 United States and Canada. Washington, D. C.:
 American Association of Museums, 1965. 52p.

Computers and Their Potential Applications in Museums;
 a Conference Sponsored by the Metropolitan Mu-
 seum of Art, April 15, 16, 17, 1968. New York:
 Arno Press, 1968. 402p.

Dudley, Dorothy H. Museum Registration Methods.
 By Dorothy H. Dudley, Irma Bezold Wilkinson,
 and others. Revised edition. Washington, D. C.:
 American Association of Museums, 1968. 294p.

Guthe, Carl Eugen. So You Want a Good Museum: a
 Guide to the Management of Small Museums.
 Washington, D. C.: American Association of

Museums, 1957. 37p. American Association of
Museums. Publication. New series no. 17.

Handbook of Museums: Germany, Austria, Switzerland.
(Handbuch der Museen: Deutschland BRD, DDR,
Oesterreich, Schweiz.) Munich, Germany: Verlag
Dokumentation, 1971. 2 v. 1,300p. (Distrib-
uted in Western Hemisphere by R.R. Bowker.)

Henry Francis du Pont Winterthur Museum. Winter-
thur Seminar on Museum Operation and Connois-
seurship, June 4-15, 1956; a Résumé of Papers
and Discussions. Winterthur, Delaware: The
Henry Francis du Pont Winterthur Museum,
1956. 49p.

_____. Winterthur Seminar on Museum Operation
and Connoisseurship, June 3-8, 1957; a Résumé
of Papers and Discussions. Winterthur, Dela-
ware: The Henry Francis du Pont Winterthur
Museum, 1957. 61p.

Howard, Richard Foster. Museum Security. Wash-
ington, D.C.: American Association of Museums,
1958. 12p. American Association of Museums.
Publication. New series no. 18.

International Institute for Conservation of Historic and
Artistic Works. Recent Advances in Conserva-
tion, Contributions to the IIC Rome Conference,
1961. Edited by G. Thomson. London: Butter-
worths, 1963. 224p.

Keck, Caroline. A Handbook on the Care of Paintings,
for Historical Agencies and Small Museums.
Nashville, Tennessee: American Association for
State and Local History, 1965. 132p.

Lerman, Leo. The Museum: One Hundred Years and
the Metropolitan Museum of Art. Introduction by
Thomas P.F. Hoving. New York: Viking, 1969.
400p.

Los Angeles County, California. County Museum of
 Art, Los Angeles. A Report on the Art and
 Technology Program of the Los Angeles County
 Museum of Art, 1967-1971. Introduction by
 Maurice Tuchman. Los Angeles: County Muse-
 um of Art, 1971. 387p.

A Museum for the People; a Report of Proceedings at
 the Seminar on Neighborhood Museums, held
 November 20, 21, and 22, 1969, at MUSE, the
 Bedford Lincoln Neighborhood Museum in Brook-
 lyn, New York. Edited by Emily Dennis Harvey
 and Bernard J. Friedberg. New York: Arno
 Press, 1971. 86p.

Museums of the World (Die Museen der Welt). Munich,
 Germany: Verlag Dokumentation, 1972. 1,200p.
 (Distributed in Western Hemisphere by R.R.
 Bowker.)

The Official Museum Directory: United States, Can-
 ada; 1971. Washington, D.C.: American Asso-
 ciation of Museums, 1970. 1,022p.

Professional Practices in Art Museums. New York:
 Association of Art Museum Directors, 1971.
 28p.

Rogers, Lola Eriksen. Museums and Related Institu-
 tions; a Basic Program Survey. Washington,
 D.C.: U.S. Office of Education; for sale by the
 Superintendent of Documents, U.S. Government
 Printing Office, 1969. 120p.

Spaeth, Eloise. American Art Museums: an Introduc-
 tion to Looking. Revised edition. New York:
 McGraw-Hill, 1969. 321p.

Tamarind Lithography Workshop. Acquiring an In-
 ventory of Original Prints — an Art Market
 Study. Prepared by Calvin J. Goodman. Los
 Angeles: Tamarind Lithography Workshop, 1969.
 53p.

_____. Business Methods for a Lithography Work-
shop. Prepared by Calvin J. Goodman. Los
Angeles: Tamarind Lithography Workshop, 1967.
240p.

_____. Gallery Facility Planning for Marketing
Original Prints. Los Angeles: Tamarind Lithog-
raphy Workshop, 1967. 36p.

_____. How a Lithograph Is Made — and How Much
It Costs. Los Angeles: Tamarind Lithography
Workshop, 1966. 18p.

_____. A Management Study of an Art Gallery; Its
Structure, Sales and Personnel. Los Angeles:
Tamarind Lithography Workshop, 1966. 110p.

_____. Sex Differentials in Art Exhibition Reviews:
a Statistical Study. Los Angeles: Tamarind
Lithography Workshop, 1972. 132p.

_____. A Study of the Marketing of the Original
Print. Based on A Study of the Marketing of
Fine Prints to Serve Contemporary American Art-
ists. Prepared by Calvin J. Goodman. Los An-
geles: Tamarind Lithography Workshop, 1964.
94p.

Tomkins, Calvin. Merchants and Masterpieces: the
Story of the Metropolitan Museum of Art. New
York: E. P. Dutton, 1970. 383p.

United Nations Educational, Scientific and Cultural Or-
ganization. The Organization of Museums; Prac-
tical Advice. Paris: United Nations Educational,
Scientific and Cultural Organization, 1960. 188p.

Wittlin, Alma S. Museums: In Search of a Usable
Future. Cambridge, Massachusetts: M. I. T.
Press, 1970. 299p.

X. MUSIC

Adizes, Ichak. Seattle Opera Association; a Policy
 Making Case for Management in the Arts. Los
 Angeles: Graduate School of Management, Uni-
 versity of California, 1971. 53p. Management
 in the Arts Research Papers no. 5.

American Symphony Orchestra League. Study Commit-
 tee. Study of Legal Documents of Symphony Or-
 chestras. Charleston, West Virginia: American
 Symphony Orchestra League, 1958. 61p.

Arian, Edward. Bach, Beethoven, and Bureaucracy:
 the Case of the Philadelphia Orchestra. Univer-
 sity, Alabama: University of Alabama Press,
 1971. 158p.

Arts Council of Great Britain. A Report on Orchestral
 Resources in Great Britain, 1970. London: Arts
 Council of Great Britain, 1970. 125p.

Berk, Lee Eliot. Legal Protection for the Creative
 Musician. Boston: Berklee Press, 1970. 371p.

Blaine, Martha. The Parkview Symphony: Cases A
 and B. Los Angeles: Graduate School of Manage-
 ment, University of California, 1971. 20p. Man-
 agement in the Arts Research Papers no. 10.

Federal Bar Association of New York, New Jersey and
 Connecticut. Committee on the Law of the The-
 atre. The Business and Law of Music; a Sympo-
 sium. Edited by Joseph Taubman. New York:
 Federal Legal Publications, 1965. 111p.

Finkelstein, Herman. Public Performance Rights in

Music and Performance Right Societies. Revised
edition. New York: 1961. 28p.

Garrison, Lee C. Comparative Profiles of Users and
Nonusers of the Los Angeles Music Center. By
Lee C. Garrison and Christina Vogl Kaali-Nagy.
Los Angeles: Graduate School of Management,
University of California, 1971. 38p. Manage-
ment in the Arts Research Papers no. 13.

Huntley, Leston. The Language of the Music Business;
a Handbook of Its Customs, Practices and Pro-
cedures. Nashville, Tennessee: Del Capo Pub-
lications, 1965. 465p.

International Music Industry Conference, 1st, Paradise
Island, Nassau, 1969. The Complete Report of
the First International Music Industry Conference.
Edited by Paul Ackerman and Lee Zhito. New
York: Billboard Publishing Company, 1969. 335p.

Karshner, Roger. The Music Machine. Los Angeles:
Nash Publishing Company, 1971. 196p.

Mueller, John Henry. The American Symphony Orches-
tra; a Social History of Musical Taste. Bloom-
ington: Indiana University Press, 1951. 437p.

Murphy, Judith. Music in American Society; an Inter-
pretive Report of the Tanglewood Symposium. By
Judith Murphy and George Sullivan. Washington,
D.C.: Music Educators National Conference,
1968. 72p.

The Music Educator's Business Handbook. Washington,
D.C.: Music Industry Council, 1970.

The Musician's Guide. New York: Music Information
Service, Inc., 1972. 1,014p.

Nimmer, Melville B. Nimmer on Copyright; a Trea-
tise on the Law of Literary, Musical and Artistic

Property, and the Protection of Ideas. Albany,
New York: Mathew Bender, 1963-. looseleaf.

Pauly, Reinhard G. Music and the Theatre: an Intro-
duction to Opera. Englewood Cliffs, New Jersey:
Prentice-Hall, 1970p. 462p.

Refior, Everett Lee. The American Federation of
Musicians: Organization, Policies, and Practices.
Chicago: 1955. University of Chicago Master's
Thesis.

Roth, Ernst. The Business of Music; Reflections of a
Music Publisher. New York: Oxford University
Press, 1969. 269p.

Rothenberg, Stanley. Legal Protection of Literature,
Art and Music. New York: Clark Boardman,
1960. 367p.

Schlesinger, Janet. Challenge to the Urban Orchestra;
the Case of the Pittsburgh Symphony. Released
through the generosity of Eastern Gas and Fuel
Associates, 1971; available from University of
Pittsburgh. 163p.

Shemel, Sidney. More About This Business of Music.
By Sidney Shemel and M. William Krasilovsky.
Edited by Lee Zhito. New York: Billboard Pub-
lishing Company, 1967. 160p.

_____. This Business of Music. By Sidney Shemel
and M. William Krasilovsky. Edited by Paul
Ackerman. Revised edition. New York: Bill-
board Publishing Company, 1971. 575p.

Smith, Cecil M. Worlds of Music. Philadelphia:
J. B. Lippincott, 1952. 328p.

Spiegel, Irwin O. Record and Music Publishing Forms
of Agreement in Current Use. Compiled and
edited by Irwin O. Spiegel and Jay L. Cooper.
New York: Law-Arts, 1971. 859p.

Swoboda, Henry, compiler. The American Symphony
 Orchestra. New York: Basic Books, 1967.
 208p.

XI. NOVELS ABOUT BUSINESS AND THE ARTS

Brodeur, Paul. The Stunt Man. New York: Atheneum, 1970. 278p.

Broun, Daniel. The Production; a Novel of the Broadway Theater. New York: Dial, 1970. 369p.

Carter, Robert A. Manhattan Primitive. New York: Stein and Day, 1971. 249p.

Creasey, John. Gideon's Art. By J.J. Marric. New York: Harper and Row, 1971. 217p.

Davis, Christopher. The Producer. (An "autobiography.") New York: Harper and Row, 1972. 321p.

Dennis, Patrick. How Firm a Foundation. New York: Pocket Books, 1969, c1968. 248p.

Gerson, Noel B. Jefferson Square. New York: M. Evans; distributed in association with Lippincott, 1968. 503p.

_____. Talk Show. New York: Morrow, 1971. 320p.

Irving, Clifford. Fake: the Story of Elmyr de Hory, the Greatest Art Forger of Our Time. (A "biography.") New York: McGraw-Hill, 1969. 243p.

Marks, Peter. Collector's Choice. New York: Random House, 1972. 211p.

O'Neal, Cothburn. The Money Hunters: a Behind-the-Scenes Novel of Professional Fund-Raisers. New York: Crown, 1966. 218p.

51

Prior, Allan. The Contract. New York: Simon and
 Schuster, 1971, c1970. 376p.

Russcol, Herbert. Philharmonic. By Herbert Russcol
 and Margalit Banai. New York: Coward, Mc-
 Cann and Geoghegan, 1971. 298p.

Selcamm, George. Fifty-Seventh Street. New York:
 Norton, 1971. 344p.

XII. THE PERFORMING ARTS

Adizes, Ichak. The Unique Character of Performing
Arts Organizations and the Functioning of Their
Boards of Directors (a Managerial Analysis).
Los Angeles: Graduate School of Management,
University of California, 1971. 14p. Manage-
ment in the Arts Research Papers no. 4.

Arts Council of Great Britain. A Report on Opera and
Ballet in the United Kingdom, 1966-69. London:
Arts Council of Great Britain, 1969. 80p.

Association of College and University Concert Manag-
ers. ACUCM Workbook; a Guide to Presenting
the Performing Arts on College and University
Campuses. Prepared by Fannie Taylor. Madi-
son, Wisconsin: Association of College and Uni-
versity Concert Managers, 1968. 117p.

Baumol, William J. Performing Arts, the Economic
Dilemma; a Study of Problems Common to The-
ater, Opera, Music and Dance. By William J.
Baumol and William G. Bowen. New York:
Twentieth Century Fund, 1966. 582p.

Beverly Hills Bar Association. Program on Legal
Aspects of the Entertainment Industry. Co-spon-
sored with the University of Southern California
Law Center. Los Angeles: 1958-to date. An-
nual publication. (See Part VI, LEGAL ASPECTS
OF THE ARTS, for explanatory note.)

Community Support of the Performing Arts; Selected
Problems of Local and National Interest. Edited
by Allan Easton. Hempstead, New York: Hof-
stra University, 1970. 327p. Hofstra University
Yearbook of Business, series 7, 1970, v.5.

Granfield, Michael. The Live Performing Arts: Fi-
 nancial Catastrophe or Economic Catharsis. Los
 Angeles: Graduate School of Management, Uni-
 versity of California, 1971. 23p. Management
 in the Arts Research Papers no. 8.

Kraus, Richard G. History of the Dance in Art and
 Education. Englewood Cliffs, New Jersey: Pren-
 tice-Hall, 1969. 371p.

Los Angeles Dance Theatre. Grant Program (of the)
 Los Angeles Dance Theatre (and) American School
 of Dance. Hollywood, California: Los Angeles
 Dance Theatre, 1970. unpaged.

Mann, Peter H. The Provincial Audience for Drama,
 Ballet and Opera; a Survey in Leeds. A Report
 to the Arts Council of Great Britain. Leeds:
 Department of Sociological Studies, University of
 Sheffield, 1969. 80p.

Martin, Ralph G. Lincoln Center for the Performing
 Arts. Englewood Cliffs, New Jersey: Prentice-
 Hall, 1971. 192p.

Moskow, Michael H. Labor Relations in the Perform-
 ing Arts; an Introductory Survey. Foreword by
 John T. Dunlop. New York: Associated Councils
 of the Arts, 1969. 218p.

National Endowment for the Arts. Economic Aspects of
 the Performing Arts--a Portrait in Figures.
 Washington, D.C.: U.S. Government Printing
 Office, 1971. 23p.

Nimmer, Melville B. Nimmer on Copyright; a Treatise
 on the Law of Literary, Musical and Artistic
 Property, and the Protection of Ideas. Albany,
 New York: Mathew Bender, 1963-. looseleaf.

Pauly, Reinhard G. Music and the Theater, an Intro-
 duction to Opera. Englewood Cliffs, New Jersey:
 Prentice-Hall, 1970. 462p.

Rockefeller Brothers Fund. The Performing Arts:
 Problems and Prospects; Rockefeller Panel Re-
 port on the Future of Theatre, Dance, Music in
 America. New York: McGraw-Hill, 1965. 258p.

Taubman, Joseph. Performing Arts Management and
 the Law. New York: Law-Arts, 1972.

Twentieth Century Fund. Task Force on Performing
 Arts Centers. Bricks, Mortar and the Perform-
 ing Arts; Report. Background paper by Martin
 Mayer. New York: Twentieth Century Fund,
 1970. 99p.

United Nations Educational, Scientific and Cultural
 Organization. The Performing Arts in Asia.
 Edited by James R. Brandon. New York: United
 Nations Educational, Scientific and Cultural Or-
 ganization, 1971. 168p.

XIII. SOCIETY AND THE ARTS

Adizes, Ichak. Arts, Society and Administration: the Role and Training of Arts Administrators. By Ichak Adizes and William McWhinney. Los Angeles: Graduate School of Management, University of California, 1971. 16p. Management in the Arts Research Papers no. 9.

The Arts and Man; a World View of the Role and Function of the Arts in Society. Englewood Cliffs, New Jersey: Prentice-Hall, 1969. 171p.

The Arts and the Public. Essays by Saul Bellow and others. Edited by James E. Miller and Paul D. Herring. Chicago: University of Chicago Press, 1967. 266p.

The Arts at the Grass Roots. Edited by Bruce Cutler. Lawrence: University of Kansas Press, 1968. 270p.

Arts Council of Great Britain. Changes and Moves; 23rd Annual Report and Accounts, Year Ended 31 March 1968. London: Arts Council of Great Britain, 1968. 113p.

_____. The 24th Annual Report and Accounts, Year Ended March 1969. London: Arts Council of Great Britain, 1969. 133p.

Arts Councils of America. The Arts: a Central Element of a Good Society; Eleventh National Conference, June 16-19, 1965, Washington, D.C. New York: Arts Councils of America, 1966. 145p.

Associated Councils of the Arts. The Arts: Planning
 for Change; Proceedings of the Twelfth National
 Conference, Associated Councils of the Arts,
 Formerly Arts Councils of America, May 19-21,
 1966, New York. New York: Associated Coun-
 cils of the Arts, 1966. 131p.

Center for the Study of Democratic Institutions. The
 Arts in a Democratic Society. By Gifford Phil-
 lips, including a discussion with Roger L. Stevens
 and others on the new program of federal aid for
 the arts. Santa Barbara, California: Center for
 the Study of Democratic Institutions, 1966. 35p.

Community Support of the Performing Arts; Selected
 Problems of Local and National Interest. Edited
 by Allan Easton. Hempstead, New York: Hofstra
 University, 1970. 327p. Hofstra University
 Yearbook of Business, series 7, 1970, v. 5.

Corson, John Jay. Business in the Humane Society.
 New York: McGraw-Hill, 1971. 314p.

Murphy, Judith. The Arts and the Poor; New Chal-
 lenge for Educators. By Judith Murphy and
 Ronald Ross. Washington, D.C.: U.S. Office
 of Education, Bureau of Research, 1968. 42p.

Peterson, Theodore Bernard. The Mass Media and
 Modern Society. By Theodore Bernard Peterson
 and Jay W. Jensen. New York: Holt, Rinehart
 and Winston, 1965. 259p.

A Seminar on the Role of the Arts in Meeting the So-
 cial and Educational Needs of the Disadvantaged.
 Final report. Hanna T. Rose, principal inves-
 tigator. Brooklyn, New York: Brooklyn Museum,
 1967. 285p.

Steiner, George A. Business and Society. New York:
 Random House, 1971. 610p.

_____ . Issues in Business and Society. New York: Random House, 1972. 500p.

U. S. Department of Health, Education, and Welfare. Toward a Social Report. With an introductory commentary by Wilbur J. Cohen. Ann Arbor: University of Michigan Press, 1970. 101p.

Wilson, Robert Neal, editor. The Arts in Society. Englewood Cliffs, New Jersey: Prentice-Hall, 1964. 372p.

XIV. THE THEATER

Arts Council of Great Britain. The Theatre Today in
England and Wales; the Report of the Arts Coun-
cil Theatre Enquiry, 1970. London: Arts Coun-
cil of Great Britain, 1970. 79p.

Bax, Peter. Stage Management. Introduction by Wil-
liam Armstrong. Reprint of the 1936 edition.
New York: Benjamin Blom, 1971. 313p.

Bernheim, Alfred L. The Business of the Theatre;
an Economic History of the American Theatre,
1750-1932. Prepared on behalf of the Actors'
Equity Association by Alfred L. Bernheim, as-
sisted by Sara Harding and the staff of the Labor
Bureau, Inc. New York: Benjamin Blom, 1964.
217p.

Birkenhead, Thomas Bruce. Economics of the Broad-
way Theatre. Ann Arbor, Michigan: University
Microfilms, 1963. 254p. New School for Social
Research Thesis.

Burris-Meyer, Harold. Theaters and Auditoriums.
By Harold Burris-Meyer and Edward C. Cole.
Second edition. New York: Van Nostrand Rein-
hold, 1964. 376p.

California Theater Index, 1971: College, University
Facilities. Los Angeles: Graduate School of
Management, University of California, 1971. 46p.
Management in the Arts Research Papers no. 3.

Cheney, Sheldon. The Art Theatre: a Discussion of
Its Ideals, Its Organization, and Its Promise as
a Corrective for Present Evils in the Commercial

Theatre. New York: Alfred Knopf, 1917. 249p.
Reprint. St. Clair Shores, Michigan: Scholarly
Press, 1970.

Dodrill, Charles W. Theatre Management Selected
Bibliography. Washington, D.C.: American
Educational Theatre Association, 1966. 10p.
Mimeo.

Eek, Nathaniel Sisson. Attitudes Toward Playgoing in
a Selected Contemporary Educational Theatre
Audience. Ann Arbor, Michigan: University
Microfilms, 1960. 179p. Ohio State University
Ph.D. Dissertation.

Elsom, John. Theatre Outside London. New York:
Macmillan, 1971. 232p.

Eustis, Morton Corcoran. B'way, Inc! The Theatre
as a Business. Reprint of the 1934 edition.
New York: Benjamin Blom, 1971. 356p.

Farber, Donald C. Actor's Guide: What You Should
Know About the Contracts You Sign. New York:
DBS Publications, 1971. 134p.

_____. From Option to Opening; a Guide for the
Off-Broadway Producer. Second revised edition.
New York: DBS Publications, 1970. 134p.

_____. Producing on Broadway; a Comprehensive
Guide. New York: DBS Publications, 1969.
399p.

Federal Bar Association of New York, New Jersey and
Connecticut. Committee on the Law of the The-
atre. Financing a Theatrical Production; a Sym-
posium. Edited by Joseph Taubman. New York:
Federal Legal Publications, 1964. 499p.

Flanagan, Hallie. Arena; the History of the Federal
Theater. New York: Benjamin Blom, 1965,
c1940. 475p.

Gard, Robert E. Theater in America; Appraisal and Challenge for the National Theatre Conference. By Robert E. Gard, Marston Balch, and Pauline B. Temkin. Madison, Wisconsin: Dembar Educational Research Services, 1968. 192p.

Goldman, William. The Season; a Candid Look at Broadway. New York: Harcourt Brace and World, 1969. 432p.

Goodman, Richard Alan. An Exploration into the Administrative Support of the Creative Process: the Theater Case. By Richard Alan Goodman and Mirta Samuelson. Los Angeles: Graduate School of Management, University of California, 1970. 13p. Management in Arts Research Papers no. 6.

_____. Theatre as a Temporary System. By Richard Alan Goodman and Lawrence Peter Goodman. Los Angeles: Graduate School of Management, University of California, 1971. 15p. Management in the Arts Research Papers no. 14.

Green, Bigelow R. The Actors Equity Association, Its Functions and Policies. New Haven, Connecticut: 1959. various pagings. Master of Fine Arts Thesis, Yale.

Greenberger, Howard. The Off-Broadway Experience. Englewood Cliffs, New Jersey: Prentice-Hall, 1971. 207p.

Harvey, Michael Lance. The Actors Equity Association-League of New York Theaters Contract Dispute of 1960; a Descriptive Study. Los Angeles: 1963. 131p. UCLA Master's Thesis.

Little, Stuart W. Off-Broadway; the Prophetic Theater. New York: Coward, McCann & Geoghegan, 1972. 323p.

_____ . The Playmakers. By Stuart W. Little and
 Arthur Cantor. New York: W. W. Norton, 1970.
 320p.

Minus, Johnny. The Managers', Entertainers', and
 Agents' Book; How to Plan, Plot, Scheme,
 Learn, Perform, Avoid Dangers, and Enjoy Your
 Career in the Entertainment Industry. Holly-
 wood, California: 7 Arts Press, 1971. 732p.

Moore, Thomas Gale. The Economics of the American
 Theater. Durham, North Carolina: Duke Univer-
 sity Press, 1968. 192p.

Morison, Bradley G. In Search of an Audience; How
 an Audience Was Found for the Tyrone Guthrie
 Theatre. By Bradley G. Morison and Kay
 Fliehr. Commissioned by Associated Councils
 of the Arts. Preface by Sir Tyrone Guthrie.
 New York: Pitman, 1968. 229p.

Plummer, Gail. The Business of Show Business.
 New York: Harper and Row, 1961. 238p.

Poggi, Jack. Theater in America; the Impact of Eco-
 nomic Forces, 1870-1967. Ithaca, New York:
 Cornell University Press, 1968. 328p.

Reynolds, Edwin Carl. A Practical Approach to The-
 atrical Business Management in the College and
 University Theatre. Ann Arbor, Michigan: Uni-
 versity Microfilms, 1961. 394p. University of
 Wisconsin Ph. D. Dissertation.

Stoyle, Judith. Economic and Demographic Character-
 istics of Actors' Equity Association Membership.
 Philadelphia: Actors' Equity Association in co-
 operation with Bureau of Economic and Business
 Research, School of Business Administration,
 Temple University of the Commonwealth System
 of Higher Education, 1970.

The Theatrical Manager in England and America;

Player of a Perilous Game; Philip Henslowe,
Tate Wilkinson, Stephen Price, Edwin Booth,
Charles Wyndham. Joseph W. Donohue, Jr.,
editor. Princeton, New Jersey: Princeton Uni-
versity Press, 1971. 216p.

Watts, John Gaydon. Economics of the Broadway Le-
gitimate Theatre, 1948-1958. Ann Arbor, Mich-
igan: University Microfilms, 1969. 91p. Co-
lumbia University Thesis.

West Coast Theatrical Directory. San Jose, California:
H. M. Gousha, 1972. 324p.

Wunderlich, Bert H. The Broadway Legitimate The-
atre Industry: an Economic Study. Princeton,
New Jersey: 1962. 80p. Princeton University
Senior Thesis.

XV. THE VISUAL ARTS

American Art Directory. Forty-fourth edition. Ann
 Arbor, Michigan: R.R. Bowker, 1970. 368p.

Art at Auction: the Year at Sotheby's and Parke-
 Bernet. Annual volume. New York: Viking.

Art Prices Current. Annual volume. Hampshire,
 Great Britain: Art Trade Press Ltd.

Associated Councils of the Arts. Directory of National
 Arts Organizations. New York: Associated Coun-
 cils of the Arts, 1972. 60p.

_____. The Visual Artist and the Law. New York:
 Associated Councils of the Arts, 1971. 100p.

Bérard, Michèle. Encyclopedia of Modern Art Auction
 Prices. New York: Arco, 1971. 417p.

Chamberlain, Betty. The Artist's Guide to His Market.
 New York: Watson-Guptill, 1970. 128p.

Eagle, Joanna. Buying Art on a Budget. New York:
 Award Books, 1970, c1968. 403p.

International Auction Records. v. VII. New York:
 Editions Publisol, 1971.

International Directory of Arts, 1969-1970. Tenth edi-
 tion. New York: Editions Publisol, 1970. 2 v.
 1,988p.

Keen, Geraldine. Money and Art; a Study Based on the
 Times-Sotheby Index. New York: G.P. Putnam,
 1971. 286p.

64

Magnan, George A. Using Technical Art; an Industry
 Guide. New York: Wiley-Interscience, 1970.
 236p.

Osborne, Harold, editor. The Oxford Companion to
 Art. Oxford: Clarendon Press, 1970. 1, 277p.

Rothenberg, Stanley. Legal Protection of Literature,
 Art and Music. New York: Clark Boardman,
 1960. 367p.

Tamarind Lithography Workshop. Sex Differentials in
 Art Exhibition Reviews: a Statistical Study. Los
 Angeles: Tamarind Lithography Workshop, 1972.
 132p.

Towner, Wesley. The Elegant Auctioneers. Com-
 pleted by Stephen Varble. New York: Hill and
 Wang, 1970. 632p.

World Collectors Annuary. Annual volume. Zandvoort,
 Holland: World Collectors Annuary.

World Collectors Compendium. Voorburg, 1972. (to
 be published)

XVI. INDEXES TO JOURNAL
AND PERIODICAL LITERATURE

There is unlimited information on all aspects of the
Arts and Administration to be found in periodical litera-
ture: journals, magazines, newspapers, newsletters,
and all the various kinds of other serial publications.
A variety of indexes provide access to the vast amount
of material available. The following titles are suggested
as being the most helpful in locating references to the
subject matter of this bibliography. Suggested subject
headings are listed under each index title given.

Art Index. Quarterly with annual cumulations. New
 York: H. W. Wilson Company.

 Art
 Management
 Museum Personnel
 Museums and Art Galleries--Administration

Dissertation Abstracts International. (Formerly Dis-
 sertation Abstracts.) Monthly with annual index
 volume. Ann Arbor, Michigan: University Micro-
 films.

 This index to Ph. D. dissertations is issued in
 two parts, of which Section A: HUMANITIES AND
 SOCIAL SCIENCES is pertinent to the subject of
 the bibliography under such subject headings as

 Art Patronage
 Management
 Music--Economic Aspects
 Performing Arts--U. S. --Finance
 State Encouragment of Science, Literature, and
 Art

Theaters--Organization

University Microfilms also publishes <u>American Doctoral Dissertations.</u>

<u>Guide to the Performing Arts.</u> (Formerly published as a supplement to <u>Guide to the Musical Arts;</u> supersedes <u>Guide to Dance Periodicals.</u>) Annual. Metuchen, New Jersey: Scarecrow Press.

Copyright
Dance as Business
Labor and Laboring Classes
Music--Economic Aspects
Music Industry
Orchestras

<u>Index to Legal Periodicals.</u> Monthly, October - August; annual and three year cumulations. An author and subject index to legal periodicals and journals. New York: H. W. Wilson Company.

Censorship
Copyright
Entertainment
Foundations
Law in Arts and Literature
Taxation

<u>Michigan Index to Labor Union Periodicals.</u> Ann Arbor: Bureau of Industrial Relations, School of Business Administration, University of Michigan. Ceased publication February, 1969.

Actors and Actresses
Actors' Equity Association
Musicians, American Federation of
Musicians and Music Teachers

<u>Music Index.</u> Monthly; annual cumulation. A subject-author guide to over 270 current periodicals from the U.S., England, Canada, Australia, and 19

non-English language countries. Entries are in
the language of the country of origin. Detroit,
Michigan: Information Coordinators, Inc.

> Ballet
> Business and Performing Arts
> Dance
> Opera
> Symphony Orchestras--Financing. Manage-
> ment.

New York Times Index. 24 semi-monthly issues;
 cumulative annual index. New York: New York
 Times Company.

> Subject indexing is complete, detailed, and
> explicit. Look under all entries related to
> subject-at-hand.

Public Affairs Information Service. Bulletin. Weekly,
 September - July; fortnightly, August; cumulated
 five times a year and annually. An index to pub-
 lications (books, journals, pamphlets, and govern-
 ment documents) relating to economic and social
 affairs. New York: Public Affairs Information
 Service, Inc.

> Actors
> Art
> Museums
> Music
> Orchestras
> Performing Arts
> Theater

U.S. Government Publications. Monthly Catalog. The
 December number includes the annual index.

> Art
> Drama
> Museums
> Music
> National Foundation on the Arts and Humanities
> Symphony Orchestras

XVII. SELECTED JOURNALS AND NEWSLETTERS

INTRODUCTORY NOTE: No individual journal articles are cited as such in this bibliography. Literally hundreds of pertinent entries can be found using the indexes listed in Part XVI above and in the selected titles listed below.

ACA Report. Monthly. Sally Lauve, editor. Associated Councils of the Arts. 1564 Broadway. New York, New York 10036. Newsletter.

Art News. 1902. Monthly, September - May; quarterly, June - August. Thomas B. Hess, editor. Newsweek, Inc. 444 Madison Avenue. New York, New York 10022. Advertising. Book reviews. Illustrations. Indexed in Art Index.

Arts Business. Monthly. Business Committee for the Arts. 1270 Avenue of the Americas. New York, New York 10020. Newsletter.

Arts in Society. 1958. 3 issues per year. Edward L. Kamarck, editor. University Extension, University of Wisconsin. 606 State Street. Madison, Wisconsin 53706. Book reviews. Advertising. Illustrations. Index. Circulation 4500.

Arts Management. 1962. 5 issues per year. Alvin H. Reiss, editor. Radius Group, Inc. 408 West 57th Street. New York, New York 10019. Book reviews. Statistics. Index. Circulation: approximately 12,000. Newsletter.

Arts Reporting Service. 1970. Bi-weekly. Charles C. Mark, publisher. The Arts Reporting Service.

1230 13th Street, N. W. Washington, D. C. 20005.
Current and pertinent developments in the national arts scene. Newsletter.

Auction. 1967. Monthly. Linda Rosencrantz, editor.
200 West 57th Street. New York, New York
10019. Book reviews. Advertising. Illustrations.

BCA News. 1968. Monthly. Free. Gideon Chagy,
editor. Business Committee for the Arts. 1270
Avenue of the Americas. New York, New York
10020. Illustrations. Statistics. Circulation:
13,000. To stimulate business involvement in
the arts. Newsletter.

Billboard. (Formerly Billboard Music Week.) 1894.
Weekly. Lee Zhito, editor. Billboard Publishing Company. 165 West 46th Street. New York,
New York 10036. Advertising. Drama, radio
and television, film and record reviews. Indexed
in Music Index.

Business and Society; a Journal of Interdisciplinary Exploration. 1960. Twice annually. Bismarck
Williams, editor. Walter E. Heller College of
Business Administration, Roosevelt University.
430 South Michigan Avenue. Chicago, Illinois
60605. Trade literature. Circulation: 3500.
Indexed in Public Affairs Information Service.
Bulletin.

Business Week. 1929. Weekly. Louis Young, editor.
McGraw-Hill, Inc. 330 West 42nd Street. New
York, New York 10036. Advertising. Book reviews. Illustrations. Statistics. Index. Indexed
in Business Periodicals Index, Public Affairs Information Service Bulletin, Readers' Guide to
Periodical Literature.

Cultural Affairs. 1967-1971. Quarterly. Peter
Spackman, editor. Associated Councils of the
Arts. 1564 Broadway. New York, New York

10036. Illustrations. Controlled circulation.
(Ceased publication 1971.)

Daedalus. 1958. Quarterly. Stephen R. Graubard,
 editor. American Academy of Arts and Sciences.
280 Newton Street. Brookline Station. Boston,
Massachusetts 02146. Charts. Illustrations.
Index. Circulation: 58,000. Indexed in Public
Affairs Information Service Bulletin, Social
Sciences and Humanities Index. See especially
Volume 98, Number 1, Winter 1969, "Perspec-
tives of Business."

Dance Magazine. 1926. Monthly. William Como,
 editor. Dance Magazine, Inc. 268 West 47th
Street. New York, New York 10036. Adver-
tising. Book, film and drama reviews. Illus-
trations. Circulation: 32,000.

Drama Review; New Plays and Translations, Criticism,
 Theory, Reviews, Interviews. (Formerly Tulane
Drama Review.) Erika Munk, editor. 32 Wash-
ington Place. New York, New York 10003. Ad-
vertising. Bibliographies. Book and drama re-
views. Charts. Illustrations. Index. Circula-
tion: 20,000. Indexed in Social Sciences and
Humanities Index.

Educational Theatre Journal. 1949. Quarterly. David
 Schaal, editor. American Educational Theatre
Association. 1317 F Street, N.W. Washington,
D.C. 20004. Book and drama reviews. Sta-
tistics. Index. Circulation to membership:
6,000. Indexed in Education Index.

Fortune. 1930. Monthly. Robert Lubar, editor.
 Time Inc. 540 North Michigan Avenue. Chicago,
Illinois 60611. Advertising. Illustrations.
Book essays. Circulation: 515,000. Indexed in
Business Periodicals Index, Public Affairs In-
formation Service Bulletin, Readers' Guide to
Periodical Literature.

International Musician. 1901. Monthly. Stanley Bal-
 lard, editor. American Federation of Musicians
 of the United States and Canada. 220 Mount
 Pleasant Avenue. Newark, New Jersey 07104.
 Advertising. Illustrations. Circulation: 260,000.
 Tabloid format. Indexed in Music Index.

Monthly Labor Review. (United States Bureau of Labor
 Statistics.) 1915. Monthly. Lawrence R. Klein,
 editor. Superintendent of Documents, U.S. Gov-
 ernment Printing Office. Washington, D.C.:
 20402. Bibliographies. Book reviews. Statis-
 tics. Index. Cumulative index approximately
 every twelve years. Circulation: 13,000. In-
 dexed in Business Periodicals Index, Public Af-
 fairs Information Service Bulletin, Readers'
 Guide to Periodical Literature.

Museum News. 1952. Monthly. Michael W. Robbins,
 editor. American Association of Museums.
 2233 Wisconsin Avenue, N.W. Washington, D.C.
 20007. Advertising. Book reviews. Illustra-
 tions. Index. Circulation: 5100.

Music Journal; Educational Music Magazine. 1943.
 Monthly, September - June. Robert Cumming,
 editor. Music Journal, Inc. 1766 Broadway.
 New York, New York 10019. Advertising.
 Book reviews. Circulation: 20,000-22,000. In-
 dexed in Education Index, Music Index.

Performing Arts Review; Journal of Management &
 Law of the Arts. 1969. Quarterly. Joseph
 Taubman, editor. Law-Arts Publishers, Inc.
 453 Greenwich Street. New York, New York
 10013. Advertising. Book reviews. Charts.
 Illustrations. Statistics. Index.

Theatre Design and Technology; News on the Construc-
 tion of Theatres, New Technical Developments,
 Stage Design, Lighting, Sound, Administration.
 1965. Quarterly. United States Institute for
 Theatre Technology. 245 West 52nd Street. New

York, New York 10019. Bibliographies. Book
and drama reviews. Charts. Illustrations. Pat-
ents. Circulation to membership: 1350.

Variety. 1905. Weekly. Abel Green, editor. Va-
riety, Inc. 154 West 46th Street. New York,
New York 10036. Advertising. Film, music,
radio and television, drama, and record reviews.
Indexed in Music Index.

Washington International Arts Letter. 1962. 10 is-
sues per year. Daniel Millsaps, editor and pub-
lisher. 115 Fifth Street, S.E. Washington,
D.C. 20003. Advertising. Book reviews.
Charts. Illustrations. Circulation: 16,359.

Word From Washington. Monthly. Associated Coun-
cils of the Arts. 1564 Broadway. New York,
New York 10036. Newsletter.

NOTES: See Part XX below for publications of the
various associations, councils and other or-
ganizations.

In addition, Ulrich's International Periodicals
Directory, a Classified Guide to Current Pe-
riodicals Domestic and Foreign, 14th edition,
2 volumes, R.R. Bowker, 1970-71, "Includes
entries for over 40,000 in print periodicals
published throughout the world." The titles
are arranged according to subject, i.e., Art
Galleries and Museums, Business, Manage-
ment, Music, Theatre, etc.

XVIII. REFERENCE SOURCES

American Architects Directory. Sponsored by the
American Institute of Architects. Third edition.
Ann Arbor, Michigan: R.R. Bowker, 1970.
1,126p.

American Art Directory. Forty-fourth edition. Ann
Arbor, Michigan: R.R. Bowker, 1970. 368p.

Covers various organizations (museums, art
schools, college and university art departments)
as well as including sections on art magazines
and newspapers with art coverage, scholarships
and fellowships in the field, travelling exhibits,
etc.

Associated Councils of the Arts. Arts Centers in the
United States. New York: Associated Councils
of the Arts, 1968. 11p. Mimeo.

_____. Directory of Community Arts Councils.
New York: Associated Councils of the Arts,
1972. 51p. Mimeo.

Names, addresses, programming information on
over two hundred community arts councils across
the country. It tells what they do, how they are
financed, who staffs them, what their problems
are.

_____. Directory of National Arts Organizations.
New York: Associated Councils of the Arts, 1972.
60p.

A second edition of ACA's guide to the national
nonprofit service organizations that serve major

art forms: information on membership, purposes, activities, conferences, publications, and budgets. A directory designed to facilitate the exchange of information on services and programs available to the arts on a national level.

_____. State Arts Councils. New York: Associated Councils of the Arts, 1972. 86p.

The first comprehensive report on the activities of 50 state councils, the District of Columbia and Virgin Islands. The data covers sources and amounts of funds received, the programs on which funds were spent, as well as membership and staffing of the councils and major issues of concern. Current list of chairmen and executive directors of all councils included.

Bérard, Michèle. Encyclopedia of Modern Art Auction Prices. New York: Arco, 1971. 417p.

California Theater Index 1971: College, University Facilities. Los Angeles: Graduate School of Management, University of California, 1971. 46p. Management in the Arts Research Papers no. 3.

Foundation Directory. Marianna O. Lewis, editor. Fourth edition. New York: Columbia University Press, 1971. 642p.

Handbook of Museums: Germany, Austria, Switzerland. (Handbuch der Museen: Deutschland BRD, DDR, Österreich, Schweiz.) Munich, Germany: Verlag Dokumentation, 1971. 2 v. 1,300p.

International Auction Records. v. VII. New York: Editions Publisol, 1971.

International Directory of Arts, 1969-1970. Tenth edition. New York: Editions Publisol, 1970. 2 v. 1,988p.

The Libraries, Museums and Art Galleries Year Book

1971. Compiled and edited by Edmund V. Cor-
bett. New York: R.R. Bowker; James Clarke &
Company, 1971. 694p.

The Official Museum Directory: United States, Canada;
1971. Washington, D.C.: American Association
of Museums, 1970. 1,022p.

Geographically arranged lists of art, history, and
science museums, giving names of directors and
department heads, addresses, telephone numbers,
hours, publications, major collections and special
activities.

Osborne, Harold, editor. The Oxford Companion to
Art. Oxford: Clarendon Press, 1970. 1,277p.

Reiss, Alvin H. The Arts Management Handbook; a
Guide for Those Interested in or Involved with the
Administration of Cultural Institutions. With pref-
ace by John H. MacFadyen. New York: Law-
Arts, 1970. 655p.

U.S. Bureau of Labor Statistics. Directory of National
and International Labor Unions in the United
States, 1969. Washington, D.C.: U.S. Govern-
ment Printing Office, 1969. 121p.

West Coast Theatrical Directory. San Jose, California:
H.M. Gousha, 1972. 324p.

Who's Who in American Art. Edited by Dorothy B.
Gilbert. Sponsored by the American Federation
of Arts. Tenth edition. Ann Arbor, Michigan:
R.R. Bowker, 1970. 548p.

XIX. BIBLIOGRAPHIES

Blum, Eleanor. Basic Books in the Mass Media; an
 Annotated, Selected Booklist Covering General
 Communications, Book Publishing, Broadcasting,
 Film, Magazines, Newspapers, Advertising, In-
 dexes, and Scholarly and Professional Periodicals.
 Urbana: University of Illinois, 1972. 252p.

Dodrill, Charles W. Theatre Management Selected Bib-
 liography. Washington, D.C.: American Educa-
 tional Theatre Association, Inc., 1966. 10p.
 Mimeo.

Georgi, Charlotte. The Arts and the Art of Adminis-
 tration; a Selected Bibliography. Los Angeles:
 Graduate School of Management, University of
 California, 1970. 51p. Management in the Arts
 Research Papers no. 2.

 _____. Management and the Arts; a Selected Bib-
 liography. Los Angeles: Graduate School of
 Management, University of California, 1972. 51p.

Kaderlan, Norman. Bibliography on the Administration
 of the Arts, 1958-1969. Madison: University of
 Wisconsin Arts Council, 1969. 24p. Mimeo.

Milwaukee Public Museum. Publications in Museology.

 No. 1: Borhegyi, Stephan F., compiler. A Bib-
 liography of Museums and Museum Work,
 1900-1960. Compiled by Stephan F.
 Borhegyi and Elba A. Dodson. 72p.

 No. 2: Borhegyi, Stephan F., compiler. Bibli-
 ography of Museums and Museum Work,

77

1900-1961. Supplementary volume. Com-
piled by Stephan F. Borhegyi, Elba A.
Dodson, and Irene A. Hanson. 102p.

Quint, Barbara. Performing Arts Centers and Eco-
 nomic Aspects of the Performing Arts: a Selec-
 tive Bibliography. By Barbara Quint and Lois
 Newman. Santa Monica, California: Rand Cor-
 poration, 1969. 13p.

Rockefeller Brothers Fund. Special Studies Project.
 Arts and Education Bibliography. New York:
 Rockefeller Brothers Fund, 1967. 37p. Mimeo.

_____. Dance Bibliography. Prepared by Genevieve
 Oswald. New York: Rockefeller Brothers Fund,
 1963. 44p. Mimeo.

_____. Music-Opera Bibliography. Prepared by
 Jean Bowen. New York: Rockefeller Brothers
 Fund, 1963. 31p. Mimeo.

United States Information Agency. Information Center
 Service. Subject Bibliography 4/69; the Perform-
 ing Arts. Washington, D.C.: U.S. Government
 Printing Office, 1969. 18p. (Attention is called
 to sections on Dance, Music, Films, and Theater
 in Subject Bibliography No. 99, January 1967,
 which the present list updates.)

NOTES: See Section XX, ASSOCIATIONS, COUNCILS,
 AND OTHER ORGANIZATIONS, for addresses
 to write to request lists of publications.

 It is also noted that many of the books listed
 include excellent bibliographies: for example,
 Baumol and Bowen, Performing Arts, the
 Economic Dilemma, pages 557-560; Burgard,
 Arts in the City, pages 95-97, 113-117, 147-
 149; and Toffler, The Culture Consumers,
 pages 243-247.

XX. ASSOCIATIONS, COUNCILS, AND OTHER ORGANIZATIONS

AMERICAN ASSOCIATION OF MUSEUMS
2233 Wisconsin Avenue, N. W. , Washington, D. C. 20007
James M. Brown III, President
Kyran M. McGrath, Director
Membership: 5000

This organization represents museums on the national level; sponsors seminars, training courses, and annual conferences; maintains advisory and placement services; offers administrative and technical assistance.

Publications: Museum News, ten issues a year; AAM Bulletin, monthly; The Official Museum Directory, 1971; America's Museums; the Belmont Report, 1969; many other special reports and books.

AMERICAN FEDERATION OF ARTS
41 East 56th Street, New York, New York 10021
Alice M. Kaplan, President
Wilder Green, Director
Membership: 3000

This membership of art institutions and individuals sponsors art appreciation in the United States, particularly in localities without extensive artistic opportunities. It also seeks to foster better international understanding through the exchange of arts. It offers art critics' workshops, seminars, and other special programs and advisory services.

Publications: The American Art Directory and

Who's Who in American Art, both revised trien-
nially; various reference books and exhibition
catalogues; annual reports.

AMERICAN SYMPHONY ORCHESTRA LEAGUE
Symphony Hill, P.O. Box 66, Vienna, Virginia 22180
John S. Edwards, Chairman
Richard H. Wangerin, President
Membership: 2100 approximately

The League serves as a clearinghouse and coor-
dinating agency for all matters pertaining to
symphony orchestras. Training programs, work-
shops, an annual conference, job counseling serv-
ices, administrative assistance, research and
services are among its activities.

Publications: Symphony News, bimonthly; bulle-
tins; manuals and reports.

THE ARTS COUNCIL OF GREAT BRITAIN
105 Piccadilly, London, WIV OAU, England
Patrick Gibson, chairman
Sir Hugh Willatt, Secretary-General

The Council consists of a Chairman and not more
than nineteen other members appointed by the
Secretary of State for Education and Science. It
is responsible to Parliament through the Secre-
tary, who also appoints a Minister for the Arts.
Financial aid and subsidies are granted to perma-
nent professional symphonies, opera, ballet, and
theater companies in Great Britain.

Publications: Annual reports; catalogues; special
surveys, studies, and reports.

ASSOCIATED COUNCILS OF THE ARTS
1564 Broadway, New York, New York 10036
George M. Irwin, Chairman
John Hightower, President
Membership: 589

Until 1965 known as the ARTS COUNCILS OF
AMERICA, this association of municipal, com-
munity, and state arts councils, as well as of
community leaders and national arts organiza-
tions, serves as a central source of information
and assistance. It plans workshops and semi-
nars; conducts an extensive arts research pro-
gram; and is the secretariat for the North Amer-
ican Assembly of State and Provincial Arts Agen-
cies, Volunteer Lawyers for the Arts, and the
national Executive Committee for Community Arts
Councils.

Publications: ACA Report, monthly; ACA Word
from Washington, monthly; issues many useful
reference tools and impressive studies. Write
for the current ACA publications list.

ASSOCIATION OF AMERICAN DANCE COMPANIES, INC.
245 West 52nd Street, New York, New York 10019
Richard E. LeBlond, Jr., President
Adam A. Pinsker, Executive Director
Membership: 400

The purpose of this organization is to aid non-
profit dance companies in organizational and ad-
ministrative development. Legal aid is given by
the Volunteer Lawyers for the Arts. Workshops
in management, advisory services, job counsel-
ing, and special studies and surveys are a part
of its program. An annual award is given for
service to the Dance.

Publications: Newsletter, four issues a year;
bulletins; annual reports.

BUSINESS COMMITTEE FOR THE ARTS
1270 Avenue of the Americas, New York, New York
 10020
G.A. McLellan, President
Membership: 125

Membership is by invitation, with an effort made

to maintain representation by type of business or
industry and by geographical location. The pur-
pose of the Committee is to encourage sponsor-
ship of the arts by business, to provide informa-
tion to corporations wanting to initiate arts pro-
grams, and to represent business in cooperative
efforts with the government or private agencies.

This need for increased business involvement with
the arts was outlined in the 1965 Rockefeller Pan-
el Report. In September of 1966, the idea of the
committee was proposed by David Rockefeller,
President of the Chase Manhattan Bank, in a
speech to the National Industrial Conference
Board.

Publications: Monthly newsletters, BCA News
and Arts Business, plus many pamphlets, all
gratis; various books, such as The State of the
Arts and Corporate Support, edited by Gideon
Chagy, 1971, available at cost.

THE FOUNDATION CENTER
888 Seventh Avenue, New York, New York 10019
Thomas R. Buckman, President
Richard H. Sullivan, Chairman

The Foundation Center, incorporated in 1956 and
supported by thirteen sponsoring foundations, has
three principal functions: information, research,
and publication. It maintains nine regional de-
positories of current foundation information: the
Washington Office; Stephens Hall, University of
California, Berkeley; University Research Library,
University of California, Los Angeles; Atlanta
Public Library; The Newberry Library, Chicago;
Associated Foundation of Greater Boston; The
Danforth Foundation; Cleveland Foundation Library;
The Hogg Foundation for Mental Health, University
of Texas, Austin, Texas.

Publications: The Foundation Directory, Founda-
tion News, The Grants Index.

NATIONAL ENDOWMENT FOR THE ARTS
Washington, D.C. 20506
Miss Nancy Hanks, Chairman

 The National Endowment for the Arts and the Na-
 tional Endowment for the Humanities are sister
 agencies. These two Endowments are the prima-
 ry components of the National Foundation on the
 Arts and the Humanities, a federal government
 agency established by Congress in September
 1965. Each Endowment has it own Advisory
 Council. The National Council on the Arts pro-
 vides advice on policies, procedures, and grant
 applications to the Chairman of the National En-
 dowment for the Arts. The National Endowment
 for the Humanities has its own Advisory Council.

 The National Endowment for the Arts' role is to
 aid and encourage the Arts in America, primarily
 through grant-making of Congressionally appro-
 priated funds. The Endowment makes grants both
 directly to artists and arts organizations across
 the country and indirectly, under the Federal-
 State Partnership Program, through funds made
 available to official State Arts Councils for use
 in their own states or regions.

ROCKEFELLER BROTHERS FUND
30 Rockefeller Plaza, New York, New York 10020
Laurance S. Rockefeller, Chairman

 Grants are made to philanthropic organizations
 in New York City and also on national and inter-
 national levels to support a variety of interests,
 in this particular case, the visual and performing
 arts. This organization sponsored a landmark
 study in this field, The Performing Arts: Prob-
 lems and Prospects; Rockefeller Panel Report
 on the Future of Theatre, Dance, Music in Amer-
 ica (McGraw-Hill, 1965).

NOTE: See the Encyclopedia of Associations, seventh
 edition, Gale Research Company, 1972, three
 volumes. Volume I lists and fully describes
 nearly 16,000 associations and professional
 societies. Section 5, on "Educational and
 Cultural Organizations," pages 447-636, cites
 many which are of special interest in Arts
 Administration.

 See also the Foundation Directory, fourth edi-
 tion, prepared by the Foundation Center and
 distributed by the Columbia University Press,
 1971.

 The Directory of National Arts Organizations,
 compiled by the Associated Councils of the
 Arts, second edition, 1972, is a particularly
 useful descriptive listing of some fifty-two
 "Membership Associations Serving the Arts."

ABINGDON PRESS. 201 Eighth Avenue South, Nash-
ville, Tennessee 37203.

ACADEMIC MEDIA, INC. Division of Computing and
Software, Inc. 32 Lincoln Avenue, Orange, New
Jersey 07050.

ADVISORY COMMISSION ON FINANCING THE ARTS
IN ILLINOIS. Room 2000, 160 North La Salle
Street, Chicago, Illinois 60601.

AMERICAN ACADEMY OF ARTS AND SCIENCES. 280
Newton Street, Brookline Station, Boston, Massa-
chusetts 02146.

AMERICAN ACADEMY OF POLITICAL AND SOCIAL
SCIENCES. 3937 Chestnut Street, Philadelphia,
Pennsylvania 19104.

AMERICAN ASSOCIATION FOR STATE AND LOCAL
HISTORY. 1315 Eighth Avenue South, Nashville,
Tennessee 37203.

AMERICAN ASSOCIATION OF MUSEUMS. 2233 Wis-
consin Avenue, North West, Washington, D.C.
20007.

AMERICAN COLLEGE PUBLIC RELATIONS ASSOCIA-
TION. One Dupont Circle, Washington, D.C.
20036.

AMERICAN EDUCATIONAL THEATRE ASSOCIATION,
INC. John F. Kennedy Center for the Perform-
ing Arts, 726 Jackson Place, North West, Wash-
ington, D.C. 20566.

AMERICAN FEDERATION OF ARTS. 41 East 56th
Street, New York 10021.

AMERICAN FEDERATION OF MUSICIANS OF THE
UNITED STATES AND CANADA. 220 Mount
Pleasant Avenue, Newark, New Jersey 07104.

AMERICAN SYMPHONY ORCHESTRA LEAGUE. Sym-
phony Hill, P.O. Box 66, Vienna, Virginia
22180.

ARCO PUBLISHING COMPANY, INC. 219 Park
Avenue South, New York 10003.

ARNO PRESS, INC. 330 Madison Avenue, New York
10017.

ART TRADE PRESS, LTD. 23 Wade Court Road,
Havant, Hampshire, Great Britain.

ARTISTS EQUITY ASSOCIATION. 229 Broadway East,
Seattle, Washington 98102.

ARTS COUNCIL OF GREAT BRITAIN. 105 Piccadilly,
London W1V OAU.

ARTS COUNCILS OF AMERICA. See ASSOCIATED
COUNCILS OF THE ARTS.

THE ARTS REPORTING SERVICE. 1230 13th Street,
North West, Washington, D.C. 20005.

ASSOCIATED COUNCILS OF THE ARTS. 1564 Broad-
way, New York 10036.

ASSOCIATION OF AMERICAN DANCE COMPANIES,
INC. 245 West 52nd Street, New York 10019.

ASSOCIATION OF ART MUSEUM DIRECTORS. Box
620, Lenox Hill Post Office, New York 10021.

ASSOCIATION OF COLLEGE AND UNIVERSITY CON-
CERT MANAGERS. P.O. Box 2137, Madison,

Wisconsin 53701.

ATHENEUM PUBLISHERS. 122 East 42nd Street, New York 10017.

AUCTION. 200 West 57th Street, New York 10019.

AWARD BOOKS. See UNIVERSAL PUBLISHING & DISTRIBUTING CORPORATION.

BARRIE AND ROCKLIFF. 2 Clement's Inn, London W.C.2.

BASIC BOOKS, INC., PUBLISHERS. 404 Park Avenue South, New York 10016.

MATTHEW BENDER & COMPANY, INC. 1275 Broadway, Albany, New York 12204.

BERKLEE PRESS. 1140 Boylston Street, Boston, Massachusetts 02115.

BILLBOARD PUBLISHING COMPANY. 165 West 46th Street, New York 10036.

BENJAMIN BLOM. 2521 Broadway, New York 10025.

CLARK BOARDMAN COMPANY, LTD. 435 Hudson Street, New York 10014.

R.R. BOWKER COMPANY. 1180 Avenue of the Americas, New York 10036.

BROOKLYN MUSEUM. Eastern Parkway, Brooklyn, New York 11238.

BUSINESS COMMITTEE FOR THE ARTS, INC. Mezzanine Suite 7, 1270 Avenue of the Americas, New York 10020.

BUTTERWORTH & COMPANY (PUBLISHERS), LTD. 88 Kingsway, London W.C.2.

CALIFORNIA ARTS COMMISSION. Document Section,
 Department of General Services. P.O. Box 1612,
 Sacramento, California 95802.

CENTER FOR THE STUDY OF DEMOCRATIC INSTI-
 TUTIONS. Box 4068, 2056 Eucalyptus Hill Road,
 Santa Barbara, California 93103.

CLARENDON PRESS. See OXFORD UNIVERSITY
 PRESS, INC.

COLLEGE AND UNIVERSITY PRESS. 263 Chapel
 Street, New Haven, Connecticut 06513.

COLUMBIA UNIVERSITY PRESS. 562 West 113th
 Street, New York 10025.

COMMERCE CLEARING HOUSE, INC. 4025 West
 Peterson Avenue, Chicago, Illinois 60646.

CORNELL UNIVERSITY PRESS. 124 Roberts Place,
 Ithaca, New York 14850.

COWARD, McCANN, & GEOGHAGEN, INC. 200 Madi-
 son Avenue, New York 10016.

CROWELL-COLLIER EDUCATIONAL CORPORATION.
 866 Third Avenue, New York 10022.

CROWN PUBLISHERS, INC. 419 Park Avenue South,
 New York 10016.

DBS. See DRAMA BOOK SPECIALISTS.

DANCE MAGAZINE, INC. 268 West 47th Street, New
 York 10036.

DEL CAPO PUBLICATIONS, INC. West Melrose
 Building, Nashville Tennessee 37204.

DELL PUBLISHING COMPANY, INC. 750 Third Ave-
 nue, New York 10017.

DEMBAR EDUCATIONAL RESEARCH SERVICES, INC.
Box 1605, Madison, Wisconsin 53701.

DEPARTMENT OF HEALTH, EDUCATION AND WEL-
FARE, OFFICE OF EDUCATION. Regional Of-
fice Building, Seventh and D Streets, South West,
Washington, D.C. 20202.

THE DIAL PRESS. See DELL PUBLISHING COM-
PANY, INC.

DOUBLEDAY & COMPANY, INC. 501 Franklin Ave-
nue, Garden City, New York 11530.

DRAMA BOOK SPECIALISTS/PUBLISHERS. 150 West
52nd Street, New York 10019.

DRAMA REVIEW. New York University. 32 Wash-
ington Place, Room 73, New York 10003.

THE HENRY FRANCIS DU PONT WINTERTHUR MU-
SEUM. Winterthur, Delaware 19735.

DUKE UNIVERSITY PRESS. Box 6697 College Station,
Durham, North Carolina 27708.

E.P. DUTTON & COMPANY, INC. 201 Park Avenue
South, New York 10003.

EDITIONS PUBLISOL. P.O. Box 339, 235 East
Eighty-Fifth Street, New York 10028.

PAUL S. ERIKSSON, INC. 119 West 57th Street,
New York 10019.

M. EVANS & COMPANY, INC. 216 East 49th Street,
New York 10017.

FEDERAL LEGAL PUBLICATIONS, INC. 95 Morton
Street, New York 10014.

FOCAL PRESS, LTD. 31 Fitzroy Square, London W1P
 6BH.

FORD FOUNDATION. 320 East 43rd Street, New York
 10017.

FORDHAM UNIVERSITY PRESS. 441 East Fordham
 Road, Bronx, New York 10458.

THE FOUNDATION CENTER. 888 Seventh Avenue,
 New York 10019.

FREE PRESS. Division of Macmillan Company. 866
 Third Avenue, New York 10022.

FUNK & WAGNALLS, INC. 53 East 77th Street, New
 York 10021.

G/L TAB BOOKS. See TAB BOOKS.

GALE RESEARCH COMPANY. Book Tower, Detroit,
 Michigan 48226.

GLENCOE PRESS. Division of Macmillan Company.
 8701 Wilshire Boulevard, Beverly Hills, Califor-
 nia 90211.

H. M. GOUSHA. Box 6227, San Jose, California
 95150.

HARCOURT BRACE JOVANOVICH, INC. 757 Third
 Avenue, New York 10017.

HARPER & ROW, PUBLISHERS. 49 East 33rd Street,
 New York 10016.

HASTINGS HOUSE, PUBLISHERS, INC. 10 East 50th
 Street, New York 10016.

HAWTHORN BOOKS, INC. 70 Fifth Avenue, New York
 10011.

HILL AND WANG, INC. 72 Fifth Avenue, New York 10011.

HOBBS, DORMAN & COMPANY. 441 Lexington Avenue, New York 10017.

HOFSTRA UNIVERSITY. 1000 Fulton Avenue, Hempstead, New York 11550.

HOLT, RINEHART, & WINSTON. 383 Madison Avenue, New York 10017.

HOUGHTON MIFFLIN. 2 Park Street, Boston, Massachusetts 02107.

HUMANITIES PRESS, INC. 303 Park Avenue South, New York 10010.

INDIANA UNIVERSITY PRESS. Tenth and Morton Streets, Bloomington, Indiana 47401.

INFORMATION COORDINATORS, INC. 1435-37 Randolph Street, Detroit, Michigan 48226.

INSTITUTE OF ARTS ADMINISTRATION. Harvard University. Cambridge, Massachusetts 02138.

INSTITUTE OF INTERNATIONAL EDUCATION. 809 United Nations Plaza, New York 10017.

RICHARD D. IRWIN, INC. 1818 Ridge Road, Homewood, Illinois 60430.

ALFRED A. KNOPF, INC. 201 East 50th Street, New York 10022.

LAW-ARTS PUBLISHERS, INC. 453 Greenwich Street, New York 10013.

J. B. LIPPINCOTT COMPANY. East Washington
Square, Philadelphia, Pennsylvania 19105.

LOS ANGELES COUNTY MUSEUM OF ART. 5905
Wilshire Boulevard, Los Angeles, California
90036.

LOS ANGELES DANCE THEATRE. 7021 Hollywood
Boulevard, Los Angeles, California 90028.

THE M. I. T. PRESS. 28 Carleton Street, Cambridge,
Massachusetts 12142.

McGRAW-HILL, INC. 330 West 42nd Street, New
York 10036.

MACMILLAN COMPANY. 866 Third Avenue, New
York 10036.

MICHIGAN STATE UNIVERSITY PRESS. Box 550, East
Lansing, Michigan 48823.

MILWAUKEE PUBLIC MUSEUM. 800 West Wells
Street, Milwaukee, Wisconsin 53233.

WILLIAM MORROW & COMPANY, INC. 105 Madison
Avenue, New York 10016.

THE MUSEUMS ASSOCIATION. 87 Charlotte Street,
London W1P 2BX.

MUSIC EDUCATORS NATIONAL CONFERENCE, CON-
TEMPORARY MUSIC PROJECT. 1201 16th
Street, North West, Washington, D. C. 20036.

MUSIC INDUSTRY COUNCIL. c/o K. G. Gemeinhardt
Company, Inc., P. O. Box 788, Elkhart, Indiana
46514.

MUSIC INFORMATION SERVICE, INC. 310 Madison
Avenue, New York 10017.

MUSIC JOURNAL, INC. 1766 Broadway, New York
 10019.

NASH PUBLISHING COMPANY. 9255 Sunset Boulevard,
 Los Angeles, California 90069.

NATIONAL BUREAU OF ECONOMIC RESEARCH. See
 COLUMBIA UNIVERSITY PRESS.

NATIONAL COUNCIL ON THE ARTS. See NATIONAL
 ENDOWMENT FOR THE ARTS.

NATIONAL ENDOWMENT FOR THE ARTS. Washington,
 D.C. 20506.

NATIONAL ENDOWMENT FOR THE HUMANITIES.
 Washington, D.C. 20506.

NEW YORK GRAPHIC SOCIETY. 140 Greenwich Ave-
 nue, Greenwich, Connecticut 06830.

NEW YORK STATE COUNCIL ON THE ARTS. 250
 West 57th Street, New York 10019.

THE NEW YORK TIMES. Book Division. 229 West
 43rd Street, New York 10036.

NEWSWEEK, INC. 444 Madison Avenue, New York
 10022.

NORTHWESTERN UNIVERSITY PRESS. 1735 Benson
 Avenue, Evanston, Illinois 60201.

W.W. NORTON & COMPANY, INC. 55 Fifth Avenue,
 New York 10003.

OFFICE OF EDUCATION. Regional Office Building,
 Seventh and D Streets, South West, Washington,
 D.C. 20202.

OHIO UNIVERSITY PRESS. Administrative Annex,
 Athens, Ohio 45701.

OXFORD UNIVERSITY PRESS, INC. 200 Madison Avenue, New York 10016.

PANTHEON BOOKS, INC. Division of Random House.
201 East 50th Street, New York 10022.

PILGRIM PRESS. 1505 Race Street, Philadelphia,
19102.

PITMAN PUBLISHING CORPORATION. 6 East 43rd
Street, New York 10017.

POCKET BOOKS. 630 Fifth Avenue, New York 10020.

PRAEGER PUBLISHERS, INC. 111 Fourth Avenue,
New York 10003.

PRENTICE-HALL, INC. Englewood Cliffs, New Jersey
07632.

PRINCETON UNIVERSITY PRESS. Princeton, New
Jersey 08540.

PUBLIC AFFAIRS INFORMATION SERVICE, INC. 11
West 40th Street, New York 10018.

PUBLIC AFFAIRS PRESS. 419 New Jersey Avenue,
South East, Washington, D.C. 20003.

G. P. PUTNAM'S SONS. 200 Madison Avenue, New
York 10016.

QUEEN ANNE PRESS. 49 Poland Street, London W1
(Refer orders to MacDonald & Company, 2 Portman Street, London W1).

RADIUS GROUP, INC. 408 West 57th Street, New
York 10019.

RAND CORPORATION. 1700 Main Street, Santa
 Monica, California 90406.

RANDOM HOUSE, INC. 201 East 50th Street, New
 York 10022.

HENRY REGNERY COMPANY. 114 West Illinois Street,
 Chicago, Illinois 60610.

RENAISSANCE EDITIONS. 527 Madison Avenue, New
 York 10022.

ROCKEFELLER BROTHERS FUND. 30 Rockefeller
 Plaza, New York 10020.

ROOSEVELT UNIVERSITY. Walter E. Heller College
 of Business Administration. 430 South Michigan
 Avenue, Chicago, Illinois 60605.

ROTTERDAM UNIVERSITY PRESS. Distributed by
 HUMANITIES PRESS, INC.

RUSSELL SAGE FOUNDATION. 230 Park Avenue,
 New York 10017.

RUTGERS UNIVERSITY PRESS. 30 College Avenue,
 New Brunswick, New Jersey 08903.

ST. JAMES PRESS. 670 North Michigan Avenue,
 Chicago, Illinois 60611.

ST. MARTIN'S PRESS. 175 Fifth Avenue, New York
 10010.

SCARECROW PRESS. 52 Liberty Street, Box 656,
 Metuchen, New Jersey 08840.

SCHOCKEN BOOKS, INC. 67 Park Avenue, New York
 10016.

SCHOLARLY PRESS, INC. 22929 Industrial Drive
 East, St. Clair Shores, Michigan 48080.

SCREEN ACTORS GUILD. 7750 West Sunset Boulevard, Hollywood, California 90046.

7 ARTS PRESS, INC. 6365 Selma Avenue, Hollywood, California 90028.

A. W. SIJTHOFF'S UITGEVERSMAATSCHAPPIJ N. V. Doezastraat 1, P. O. Box 26, Leiden, Netherlands.

SIMON & SCHUSTER, INC. 630 Fifth Avenue, New York 10020.

ALFRED P. SLOAN FOUNDATION. 630 Fifth Avenue, New York 10020.

SMITHSONIAN INSTITUTION PRESS. Washington, D. C. 20560.

STEIN & DAY PUBLISHERS. 7 East 48th Street, New York 10020.

TAB BOOKS. Monterey and Pinola Avenues, Blue Ridge Summit, Pennsylvania 17214.

TAMARIND LITHOGRAPHY WORKSHOP. 1112 Tamarind, Los Angeles, California 90038.

TEACHERS COLLEGE PRESS. Teachers College, Columbia University. 1234 Amsterdam Avenue, New York 10027.

TEMPLE UNIVERSITY. Bureau of Economic and Business Research, School of Business Administration. Philadelphia, Pennsylvania 19122.

TIME, INC. 540 North Michigan Avenue, Chicago, Illinois 60611.

TWAYNE PUBLISHERS, INC. 31 Union Square West, New York 10003.

TWENTIETH CENTURY FUND. 41 East 70th Street,
New York 10021.

FREDERICK UNGAR PUBLISHING COMPANY. 250
Park Avenue South, New York 10003.

UNIPUB. Box 433, New York 10016.

UNITED NATIONS EDUCATIONAL, SCIENTIFIC, AND
CULTURAL ORGANIZATION. (UNESCO). See
UNIPUB.

U.S. GOVERNMENT PRINTING OFFICE, SUPERIN-
TENDENT OF DOCUMENTS. Washington, D.C.
20402.

UNITED STATES INSTITUTE FOR THEATRE TECH-
NOLOGY. 245 West 52nd Street, New York
10019.

UNIVERSAL PUBLISHING & DISTRIBUTING CORPORA-
TION. 235 East 45th Street, New York 10017.

UNIVERSITY MICROFILMS. 300 North Zeeb Road,
Ann Arbor, Michigan 48106.

UNIVERSITY OF ALABAMA PRESS. Drawer 2877,
University, Alabama 35486.

UNIVERSITY OF CALIFORNIA, BERKELEY. Institute
of Governmental Studies. 2223 Fulton Street,
Berkeley, California 94720.

UNIVERSITY OF CALIFORNIA, LOS ANGELES. Grad-
uate School of Management/ Division of Research.
405 Hilgard Avenue, Los Angeles, California
90024.

UNIVERSITY OF CALIFORNIA, LOS ANGELES. Li-
brary. 405 Hilgard Avenue, Los Angeles, Cali-
fornia 90024.

UNIVERSITY OF CALIFORNIA PRESS. 2223 Fulton
 Street, Berkeley, California 94720.

UNIVERSITY OF CHICAGO PRESS. 5801 Ellis Avenue,
 Chicago, Illinois 60637.

UNIVERSITY OF ILLINOIS PRESS. Urbana, Illinois
 61801.

UNIVERSITY OF KANSAS PRESS. 366 Watson Library,
 Lawrence, Kansas 66044.

UNIVERSITY OF MICHIGAN PRESS. Ann Arbor,
 Michigan 48106.

UNIVERSITY OF PENNSYLVANIA PRESS. 3933 Walnut
 Street, Philadelphia, Pennsylvania 19104.

UNIVERSITY OF PITTSBURGH. 127 North Bellefield
 Avenue, Pittsburgh, Pennsylvania 15213.

UNIVERSITY OF SHEFFIELD. See ARTS COUNCIL
 OF GREAT BRITAIN.

UNIVERSITY OF SOUTHERN CALIFORNIA. Law Cen-
 ter. University Park, Los Angeles, California
 90007.

UNIVERSITY OF WISCONSIN PRESS. P.O. Box 1379,
 Madison, Wisconsin 53701.

UNIVERSITY OF WISCONSIN, University Exten-
 sion. 606 State Street, Madison, Wisconsin
 53706.

VAN NOSTRAND REINHOLD COMPANY. Division of
 Litton Educational Publishing, Inc. 450 West
 33rd Street, New York 10001.

VARIETY, INC. 154 West 46th Street, New York
 10036.

VERLAG DOKUMENTATION SAUR KG. Distributed in the Western Hemisphere by R. R. BOWKER COMPANY.

THE VIKING PRESS, INC. 625 Madison Avenue, New York 10022.

WADSWORTH PUBLISHING COMPANY, INC. 10 Davis Drive, Belmont, California 94002.

WASHINGTON INTERNATIONAL ARTS LETTER. 115 Fifth Street, South East, Washington, D. C. 20003.

WATSON-GUPTILL PUBLICATIONS. Division of BILL-BOARD PUBLICATIONS, INC. 165 West 46th Street, New York 10036.

WILEY-INTERSCIENCE. Division of JOHN WILEY & SONS, INC. 605 Third Avenue, New York 10016.

H. W. WILSON COMPANY. 950 University Avenue, Bronx, New York 10452.

WORLD COLLECTORS ANNUARY. P. O. Box 19, Zandvoort, Holland. (Also WORLD COLLEC-TORS COMPENDIUM.)

YALE UNIVERSITY PRESS. 149 York Street, New Haven, Connecticut 16511.

This is basically an author index to the works cited in
this bibliography. Wherever the author is not clear or
the main entry is the title, and also in the case of
journals, newsletters, indexes, and other types of pe-
riodicals, the title is used. Organizations are, of
course, listed by name only.